Women Brave in the Face of Danger

Books by Margaret Randall

Risking A Somersault In The Air: Conversations with Nicaraguan Writers, Solidarity Publications, San Francisco, 1984

Christians In The Nicaraguan Revolution, New Star, Vancouver, B.C., Canada, 1983

Sandino's Daughters, New Star, Vancouver, B.C., Canada, 1981

Breaking The Silences, Poems by 25 Cuban Woman Poets, Pulp Press, Vancouver, B.C., Canada, 1981

Cuban Women: Twenty Years Later (with photographs by Judy Janda), Smyrna Press, New York, N.Y., 1980

Inside The Nicaraguan Revolution: The Story Of Doris Tijerino, New Star, Vancouver, B.C., Canada, 1978

These Living Songs, Poetry by 15 Young Cuban Poets, Colorado State University Press, 1978

Carlota: Poems And Prose From Havana, New Star, Vancouver, B.C., Canada, 1978

Spirit Of The People: Vietnamese Women Two Years From The Geneva Accords, New Star, Vancouver, B.C., Canada, 1975

Part Of The Solution, New Directions, New York, N.Y., 1972

Women Brave in the Face of Danger

PHOTOGRAPHS OF AND WRITINGS BY LATIN AND NORTH AMERICAN WOMEN

Margaret Randall

The Crossing Press
Trumansburg, New York 14886

Acknowledgments

Anonymous Papago poem, translated by Frances Densmore, adapted by Kathleen Weaver, from *The Other Voice*, Norton, 1976.

Daughters, a play by Clare Coss, Sondra Segal and Roberta Sklar.

Señora Blanca and a woman factory worker, from *The Triple Struggle, Latin American Peasant Women*, by Audrey Bronstein, WOW Campaigns, Ltd., London, 1982.

Idania Fernández, Sister Martha Deyanira Frech, Amada Pineda, Julia García, Gladys Báez, Mercedes Taleno, from *Sandino's Daughters*, by Margaret Randall, New Star, Vancouver, 1981.

Diane di Prima, from *Selected Poems 1956-1975*.

Sharon Doubiago, from *Hard Country*, West End Press, Minneapolis, 1982.

Gabriela Mistral, translated by Langston Hughes, from *The Other Voice*, Norton, 1976.

Raquel Jodorowsky, from *Ajy Tojen*, El Corno Emplumado, Mexico City, 1964.

Hettie Jones, from *Having Been Her*, # Press, New York, 1981.

Linda Gregg, from *Too Bright To See*, Graywolf Press, Port Townsend, Washington, 1981.

Rosario Castellanos, translated by Maureen Ahern, from *Looking At The Mona Lisa*, Rivelin/Ecuatorial, Bradford, England, 1981.

Haydée Santamaría and Jacinta Odilia Orozco, from *Cuban Women—20 Years Later*, by Margaret Randall, Smyrna Press, New York, 1981.

Helena Minton, from *Personal Effects*, Alice James Books, Boston, 1976.

Angela Gonzáles, from an unpublished interview with Margaret Randall.

D. Wright, from *Translations Of The Gospel Back Into Tongues*, S.U.N.Y. Press, Albany, New York, 1981.

Martina, from an unpublished interview with Margaret Randall.

Denise Levertov, from *The Sorrow Dance*, 1967, copyright © by Denise Levertov Goodman.

Ismaela Acosta and Teresa Sánchez, from *Cuban Women Now*, by Margaret Randall, The Women's Press, Toronto, 1974.

Gladys Díaz, from "Collective Reflections Of A Group Of Militant Prisoners," Venezuela, 1979.

Ann Nelson and Ana María, from *No me agarran viva, la mujer salvadoreña en lucha*, by Claribel Alegría and D.J. Flakoll, Ediciones Era, Mexico City, 1983.

Fran Baskin, from "Rebecca," from Ikon, summer/fall 1983.

Luisa Valenzuela, translated by Margaret Sayers Peden, from Open Places, #36, fall/winter 1983.

Adelía Prado, translated by Ellen Watson, from The American Poetry Review, January/February 1984.

June Jordan, from *Things That I Do In The Dark*, copyright © 1977 by June Jordan, reprinted by permission from Beacon Press.

Patricia Goedicke, from *The Dog That Was Barking Yesterday*, Lynx House Press, Amherst, Mass., 1980.

Rosemary Catacalos, from *El Camino de la Cruz, A Chicano Anthology*, Tejidos, Austin, Texas, 1981, and *Again For The First Time*, Tooth Of Time Books, Santa Fe, N.M., 1984.

Marge Piercy, from *Circles In The Water*, copyright © 1982 by Marge Piercy. Reprinted by permission of Alfred A. Knopf, Inc.

Rigoberta Menchu, translated by Patricia Goedicke.

Soledad and Margarita, from *Simplemente Explotadas*, by Alberto Rutte Garcia, Campodonico, Lima, 1973.

Joy Harjo, from *She Had Some Horses*, Thunder's Mouth Press, New York 1983.

Denise Penek, from *A Gathering Of The Spirit, Writing And Art By North American Indian Women*, edited by Beth Brant, Sinister Wisdom, Rockland, Maine.

Alaide Foppa, translated by Margaret Randall.

Edna Hopkins and Lue Rayne Culbertson, from *Good Work Sister!*, Northwest Women's History Project, Portland, Oregon.

Doris McKinney and Mary Dean, from an in-progress project by Michael Frisch and Milton Rogovin.

Domitila Barrios de Chungara, Copyright © 1978 by Monthly Review Press, reprinted by permission of Monthly Review Press.

Dominga de la Cruz, from *El pueblo no sólo es testigo: la historia de Dominga*, by Margaret Randall, Ediciones El Hurucán, Río Piedras, Puerto Rico, 1979.

Alma, from *Women at Farah, An Unfinished Story*.

Sue Doro, from "Poems of Sparrows 1978."

Lesbians, from the Buffalo Women's Oral History Project, Buffalo, New York.

Debbie Wald, unpublished poem.

Adrienne Rich, from *Nice Jewish Girls, A Lesbian Anthology*, Crossing Press, 1982.

Violeta Parra, translated by John Felstiner, from *The Other Voice*, Norton, 1976.

Ai, from *Cruelty*, copyright © 1973 by Ai, by permission from Houghton Mifflin Co.

Nancy Morejón, from *Breaking The Silences* by Margaret Randall, Pulp Press, Vancouver, 1982.

Audre Lorde, from the Massachusetts Review, winter/spring 1972.

Susan Sherman, from an unpublished manuscript.

Meridel LeSueur, from *Every Woman Has A Story*, Gayla W. Ellis, Midwest Villages and Voices, Minneapolis, 1982.

Library of Congress Cataloging in Publication Data

Randall, Margaret, 1936—
 Women brave in the face of danger.

 (The Crossing Press feminist series)
 1. Women--Latin America--Social conditions. 2. Women
--United States--Social conditions. 3. Women--Latin
America--Attitudes. 4. Women--United States--Attitudes.
I. Title. II. Series.
HQ1460.5.R333 1985 305.4'097 85-2634
ISBN 0-89594-162-7
ISBN 0-89594-161-9 (pbk.)

Introduction

Women brave in the face of danger . . .

Women *are* brave in the face of danger, and we all need to know that. We are conditioned to forget, because our essential history has been ignored, distorted, and hidden from us always. And it's not even easy to find out how and where we can look to retrieve it. Besides, we are busy. We are busy resisting—or embracing—the constant media blast which convinces us we are "a special interest group," that assures us we will never grow old (most hideous of crimes!) if we use the right cream, spa, dye, mask, language, diet, ideology, fashion, and deodorant. The media blast that allays our fears about being overlooked, co-opted, abandoned, rejected, raped, battered, murdered, or abused. The media blast that continuously reminds us we can make it, do it, have it, be it, consume it, acquire it, or even believe we are choosing it—if only we conform and confirm: to that image a screen-turned-mirror provides . . . after extracting its payment in blood.

In order to hold up another sort of mirror and show us the brave sister in the glass, this book travelled a circuitous route from its germination to what you have in your hand. Its roots undoubtedly belong to the Latin America where I lived and learned for the past 23 years; and to the United States where I was born and to which I returned ten months ago—with a mixed sense of coming home and bringing with me another consciousness in this woman now forever destined to be both "one" and "the other." And it began to struggle to life in an electric conversation between Elaine Gill and myself, in Aurora, New York in the Spring of 1984.

"Why don't you do a calendar?" she asked.

"Yes," I responded, "with pictures of women, and our words . . .".

"Yes," she affirmed, "with poetry and bits of testimony—the things women say about themselves, our own experience."

"Yes!"

The work had already begun, in my eyes and memory, and in our plans. So I started on a calendar. It was to have had an image and a text for each of the year's 52 weeks.

And I continued with the calendar, a 1986 calendar, the pages of which would remind us, in images and words from our Latin and North American sisters, that we *are* brave, we *do* resist, survive, create. Daily we would have this to remember. Weekly we would have it.

I went back over photographs I had taken of women during my last years in Mexico, Cuba, Nicaragua. What I had been able to photograph in Latin America logically outweighed and overwhelmed what I had from the United States; so I made a trip—through Arizona, California, Oregon, Washington, Idaho, Utah: seeking images of women in factories and gyms, streets and orchards. Images came, as well, from some of the cities where I read in the first months following my return to this country: Buffalo, Philadelphia, New York.

This, then, is a part of my own experience of reentry. Bringing a vision of Latin American women, filtered through the prism of my *gringa* eye. Seeing the women of North America, with eyes that are still different, eyes that are not yet totally adjusted to the media hype or resigned to a certain configuration of identity in time and space. Those particular reflections. This particular bonding.

I want to surprise women in their own space and gesture. If possible, I never engage in conversation before I have registered the image. Afterwards, yes—the more the better! A verbally articulated knowledge may help me to understand how I wish to print a particular picture. But in the moment of reception, I want a clear path between my camera's eye and what it has chosen to record.

The texts in this book are women's voices: from North and South America. They are the voices of well-known poets and composers, a Chilean recipient of the 1957 Nobel Prize for Literature, a contemporary military commander from Nicaragua, a maid in Lima, a Cuban tobacco worker (granddaughter of a slave), a peasant along the banks of the Amazon, a Guatemalan Indian woman, a shipyard welder from Portland, an ex-steel worker from Buffalo, a strike leader in El Paso. Out of their separate identities and perceptions, women who are Black, Hispanic, Native American, white, old, young, lesbian, heterosexual, mothers, daughters, and political leaders weave a fabric of unique threads, making for a rich and common vision.

And the project outgrew the calendar. Did we really want this to remain a novelty which people would buy in order to give background to a short-lived agenda? No. We came to understand it must become a book, lasting and cherished, substantial and nurturing. Something to remind us of a powerful and shared identity—through the four difficult years to come . . . and long beyond. And so this volume was born.

Finally, I want to say that there is no direct connection between image and text beyond those links—sometimes ancient, sometimes self-evident or intuited—which they sought from one another as I spread them out before me and gathered them in again, shuffled and reshuffled in an effort to create a composite statement pregnant with the possibilities our multiple consciousness reveals. I would ask you, the reader, to consider the images and texts, separately and together. And to use them to nurture and strengthen your own bravery in the face of danger!

Margaret Randall

Albuquerque
November, 1984

this book is for
my sisters in latin america
who taught me patience, struggle, and hope
and for my sisters in north america
who brought me home

this book is also for meridel lesueur:
fleshed-out spirit, giving . . .

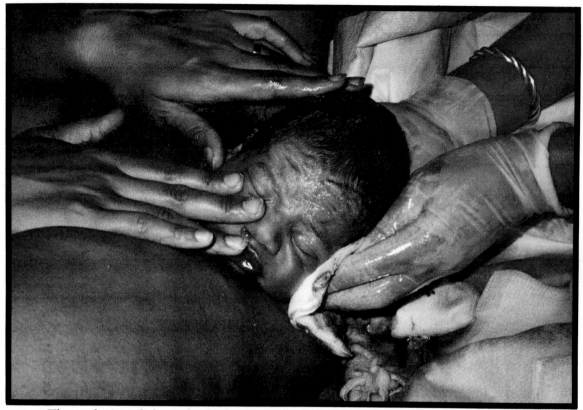

The mother's and the midwife's hands almost link about the child coming into the world.

Song of a Woman in Labor

towering rocks
sound
in the evening
with them
I cry

—Anonymous Papago

Close your eyes. Spread your legs.
Feel the heat between your legs.
Imagine yourself becoming wet.
The muscles of your legs and pelvis
pulling back. Becoming tighter and
tighter as you open.

There is a great pressure bearing down.
Bearing down inside your pelvis. Pushing down.
Pushing down as you widen.
All your muscles are pulling back.
You are splitting open.
You are looking down.
And feel.
And see.
A hard round head
emerging.
Emerging from your body.

Do you wonder why you feel so connected
to your mother?

—"Daughters"

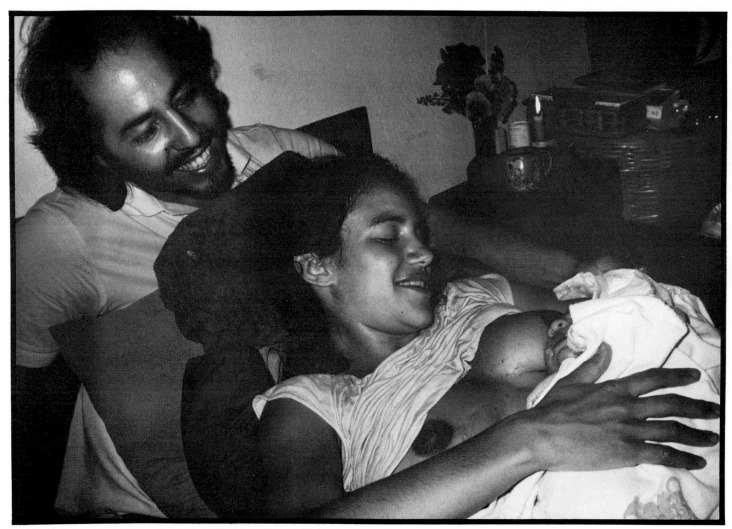

The mother is Luz, the father Edgard, the midwife Yeshi, and the child Carib.

A man falls once, and he gets up again. A
woman falls once, and she is marked forever.
A man can choose what he wants. But women
have to get married, and then come the
children. Men don't know what it's like to be a
mother and cry for a child.

—Señora Blanca, 43,
single mother of seven, Ecuador

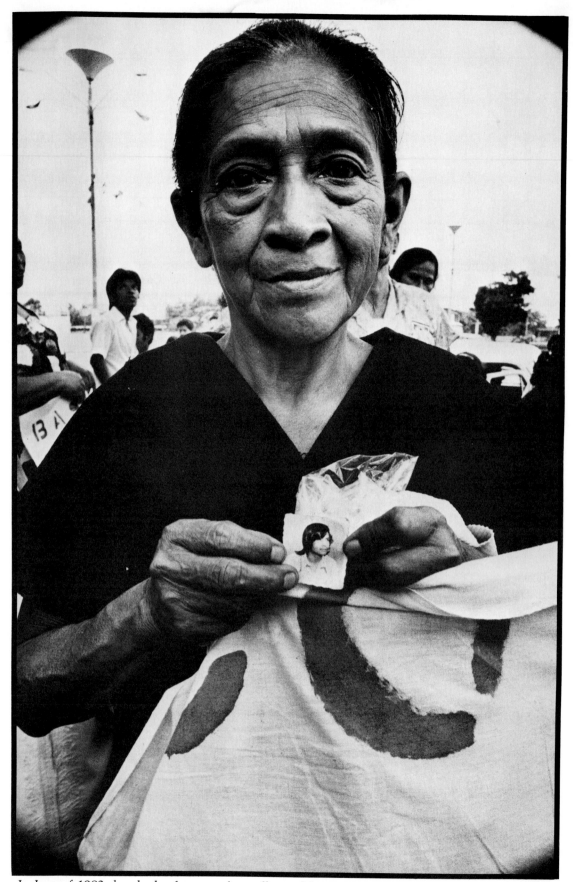

In June of 1982, hundreds of women from all over Nicaragua came together in the capital city of Managua. They had in common that they were the mothers of sons and daughters who had given their lives throughout the long struggle for freedom. They were protesting for a reinstatement of the death penalty, against the "contras" who continue to decimate their families. Some of them held tiny photos of their dead children, their only relic beside memory. But the Sandinistas, with their 1979 victory, abolished the death penalty. And it was to stay that way. Death does not bring back life, they believe.

. . . I hope that someday, not too far off, you may be able to live in a free society where you can grow and develop as human beings should, where people are brothers and sisters, not enemies. I'd like to be able to walk with you then, holding hands, walk through the streets and see everyone smiling, the laughter of the children, the parks and rivers. We ourselves smile with joy as we see our people grow like a happy child and watch them become new human beings, conscious of their responsibility toward people everywhere . . .

You must learn the value of the paradise of peace and freedom you are going to be able to enjoy. I say this because the best of our brave people have given their precious blood, and they've given it willingly, with great love for their people, for freedom and for peace, for generations to come, and for children like you. They've given their lives so our children won't have to live under the repression, humiliation and misery so many men, women and children have suffered in our beautiful Nicaragua.

I'm telling you all this in case I'm not able to tell you personally or no one else tells you these things. A mother isn't just someone who gives birth, and cares for her child; a mother feels the pain of all children, the pain of all peoples, as if they had been born of her womb . . .

—Idania Fernández
(Fragments of a letter from Nicaraguan revolutionary Idania Fernández, written to her small daughter Claudia one month before Idania was killed in battle, April 16, 1979. The letter is dated March 8th.)

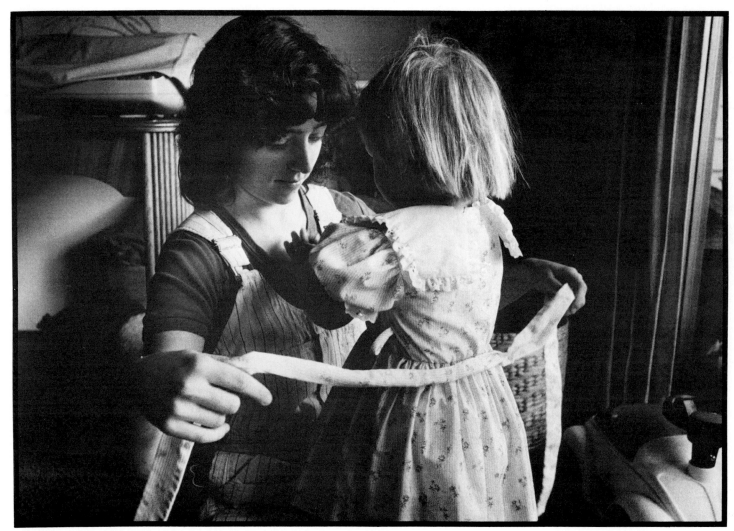

Bridget and Caitlin in Seattle.

Nightmare 12

I went to the clinic. I twisted my foot I said.

What's your name they said and age and how much do you make and who's your family dentist.

I told them and they told me to wait and I waited and they said come inside and I did.

Open your eye said the doctor you have something in it.

I hurt my foot I said.

Open your eye he said and I did and he took out the eyeball and washed it in a basin.

There he said and put it back that feels better doesn't it.

I guess so I said. It's all black I dont know. I hurt my foot I said.

Would you mind blinking he said one of your eyelashes is loose.

I think I said there's something the matter with my foot.

Oh he said. Perhaps you're right. I'll cut it off.

—Diane di Prima

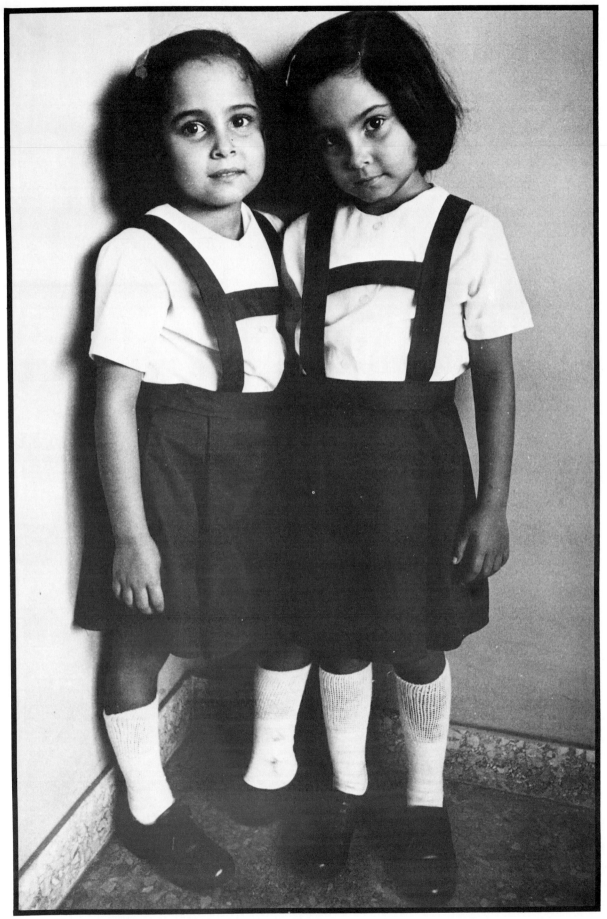

Twins, Havana, Cuba

. . .

I understand we are each stranded
in our essential Body,
my mother, my father, my sister, my brother
the neighbors, all
the people, myself

I understand we come from a truth
we each wholly and separately possess
to a particular house and street in time
to tell the story only our body knows
and our tragedy will be
we will not tell it well
because our witnesses
will be telling their stories . . .

I am large within my head that frames the window
and I understand evil
is in not understanding this

We expect the others
to live our story

I am five, I will never understand
why we are stranded in our selves
but in this moment I know
my own story
is understanding our singleness
that I am destined to move my body and time
into the body-time
the story
of Others . . .

—Sharon Doubiago

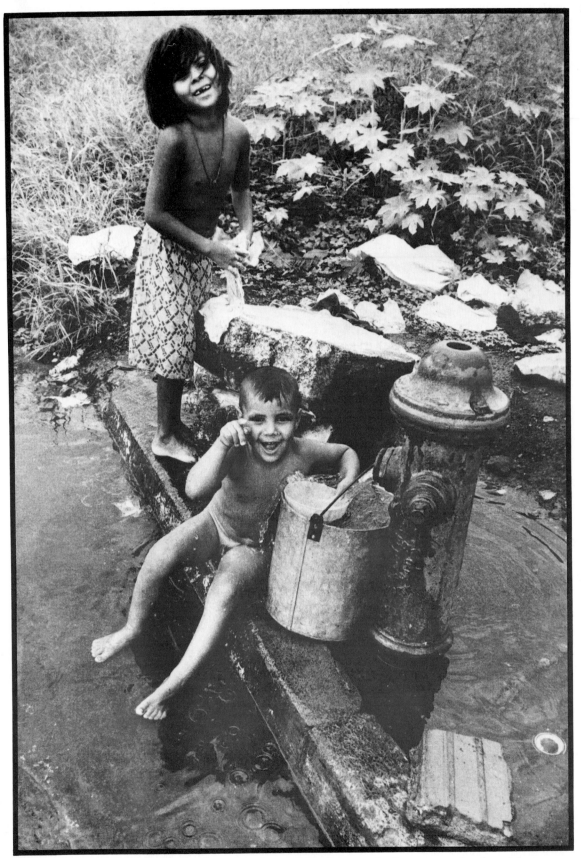

She is nine but she is already washing for others while she cares for her younger brother. Managua, Nicaragua.

Sister

Today I saw a woman plowing a furrow. Her
hips are broad, like mine, for love, and
she goes about her work bent over the earth.

I caressed her waist; I brought her home
with me. She will drink rich milk from my
own glass and bask in the shade of my ar-
bors growing pregnant with the pregnancy
of love. And if my own breasts be not gene-
rous, my son will put his lips to hers, that
are rich.

—Gabriela Mistral

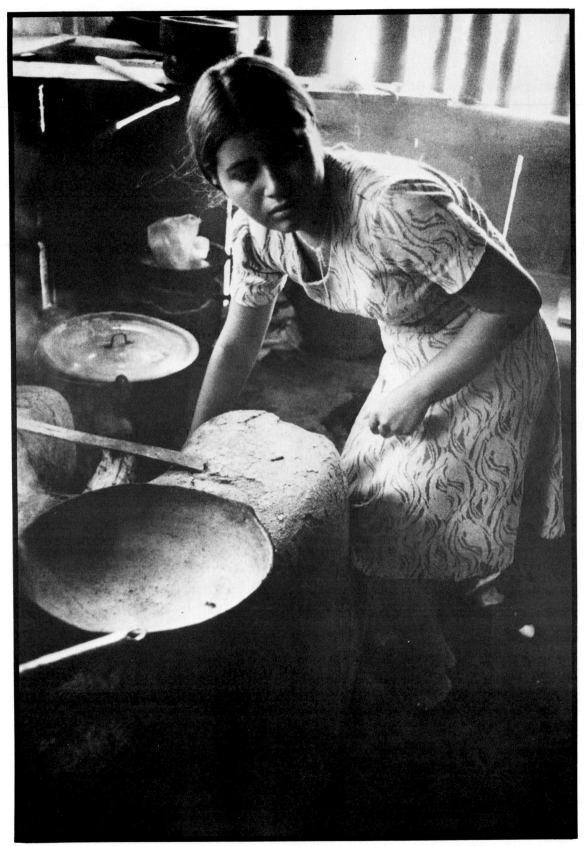

Catelina in the kitchen of her farmhouse in Nicaragua.

The Great Fat Universal Mother

. . . If I open my hand will this world fall?
Does it matter to anyone a little, a lot?
A cloud of perfumed old men passes by
on its way to a future of sleeping skeletons
in cities that howl.
Stay apart Dayal
somewhere away from all this
beyond or before
on the roof of some other country waving your man's pants
your hair hanging in pure pain
hold your younger brothers to your heart
and always die speaking or crying or cleansing or defending
die drunk, drowned in mouths, die noble
of wounds, die laughing
but never die of death. You must not die of death.
Life will hide you.
Though an oven door awaits you, don't give in
don't give up but to the evidence of love
don't even let this poem, suddenly gone sour, touch you.
A lie. Tomorrow is not another day.
It is today. Begin. In one way or another this must change
even if kisses are not enough, if blood is needed,
this must change.

—Raquel Jodorowsky

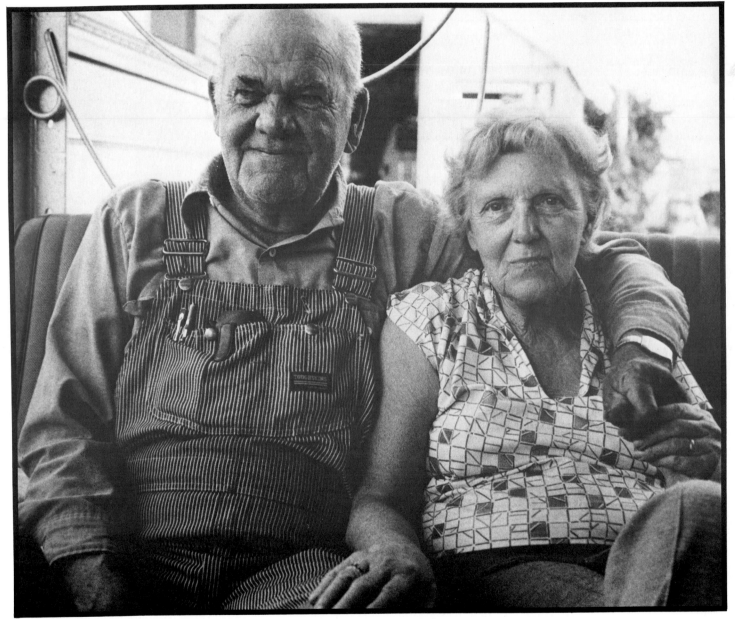

Lorene has her Alec and Alec has his Lorene in Washington's Yakima Valley.

On the bus
from Newark to New York
the baby pukes
into the fox collar
of her only coat

She wipes the collar
and the baby's soft face
then takes her toddler
by the hand
and heads for the subway

where the toddler
sleeps
at her knee
and she
 herself
stares
out the window
over the head
of the sleeping baby

She is twenty-six years old
and very tired
 Let me always
support her
 Having been her
befriend her

—Hettie Jones

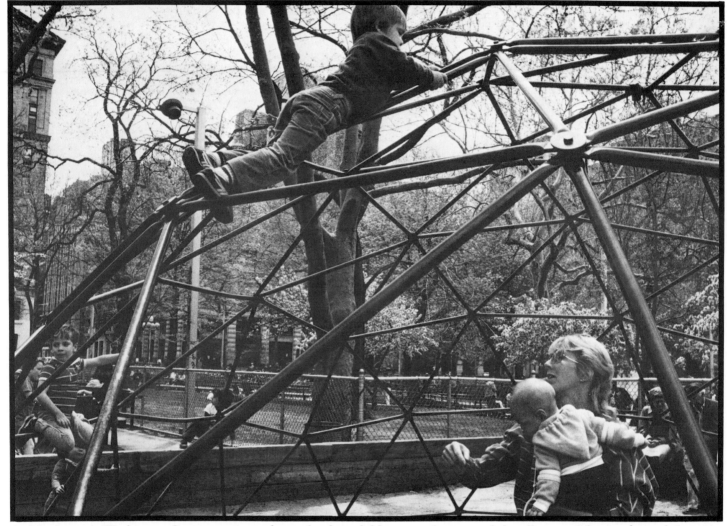

In Manhattan's Washington Square young mothers take their children out of overcrowded walkups to "play in the park."

The Girl I Call Alma

The girl I call Alma who is so white
is good, isn't she? Even though she does not speak,
you can tell by her distress that she is
just like the beach and the sea, isn't she?
And she is disappearing, isn't that good?
And the white curtains, and the secret smile
are just her way with the lies, aren't they?
And that we are not alone, ever.
And that everything is backwards
otherwise.
And that inside the no is the yes. Isn't it?
Isn't it? And that she is the god who perishes:
the food we eat, the body we fuck,
the loose net we throw out that gathers her.
Fish! Fish! White sun! Tell me we are one
and that it's the others who scar me,
not you.

—Linda Gregg

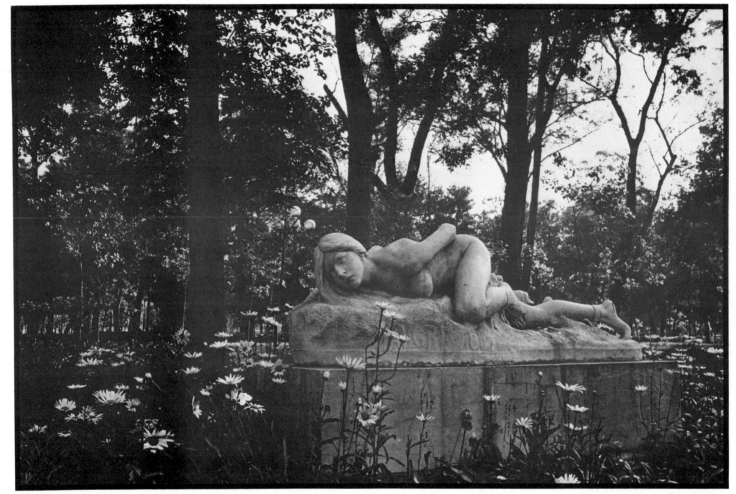

In Mexico City's Alameda Park, this statue is surrounded by busts of presidents and Aztec warriors. The inscription: "In spite of all . . .", written in French.

Passport

A woman of ideas? No, I've never had a single one.

I've never repeated other people's ideas either (out of
Modesty or just bad memory).
A woman of action? Not that either.
Just look at the size of my hands and feet.

A woman of word, then. No, my word no.
But yes, indeed of words,
a lot of contradictory, insignificant ones,
pure sound, a sifted vacuum of arabesques,
parlour games, gossip, froth, forgetting.

If you need a definition
for the identity form, just write down
that I'm a woman of good intentions
who's paved a straight and easy road to hell.

—Rosario Castellanos

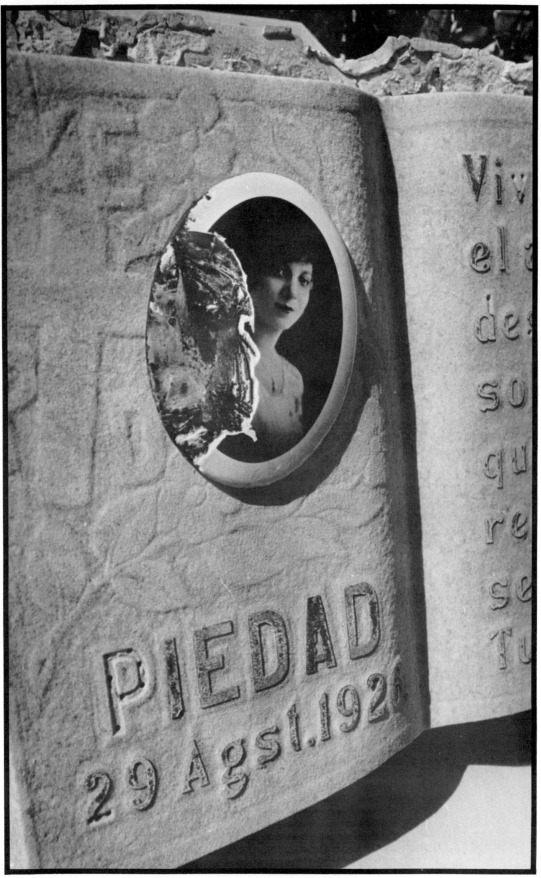

On a tombstone in Havana's Colón Cemetery, a woman who died more than a half a century ago, Pilar, is remembered with a chipped enamel cameo of her face.

. . . Nicaraguan women hold Mary the Mother of God as their first model for promoting this revolution. She, too, carried to the world a message of liberation . . . Mary isn't the sugar-sweet and stupid woman reactionary Christians so often make her out to be. At the age of 15, the same age as Doris María Tijerino,* she took an active part in her people's liberation. And she doesn't talk about individual moralistic changes, but of the reorganization of the social order . . . Nicaraguan women must follow the path begun by Mary of Nazareth and Doris María of Matagalpa. We have but one alternative: to be women of hope . . .

—Sister Martha Deyanira Frech

*Doris María Tijerino, revolutionary leader and childhood friend of Sister Martha's, also from Matagalpa.

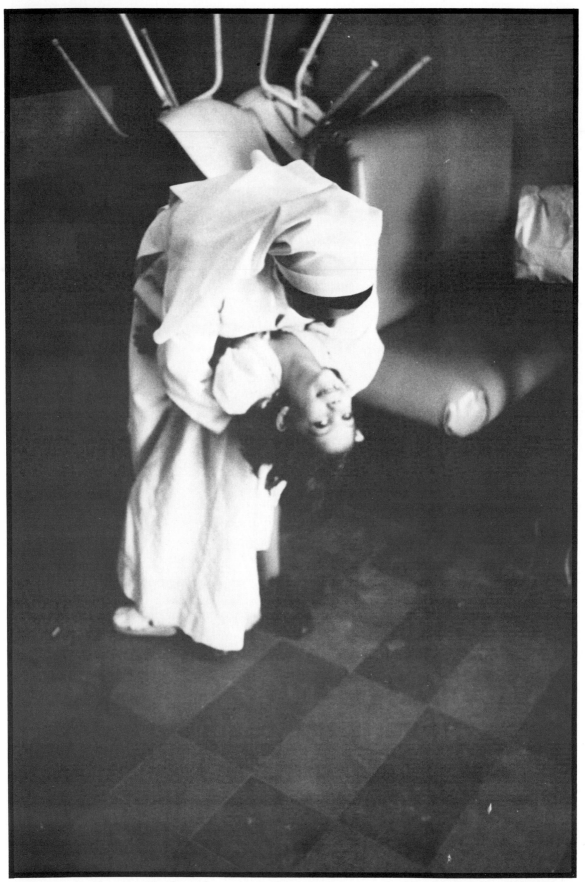

Sister Martha Deyanira Frech, with so many others, was active in the Nicaraguan war of liberation. Here she holds little Dorís Maria.

The revolution gave their dignity back to
human beings; it didn't give it back to man
alone because I don't think the word man in-
cludes women. I don't agree that when one is
going to talk about human beings one should
say "man." I don't think men would agree that
our saying "women" when we mean men and
women really includes them.

—Haydée Santamaría
Heroine of Moncada, leader of
the Cuban Revolution, died 1980.

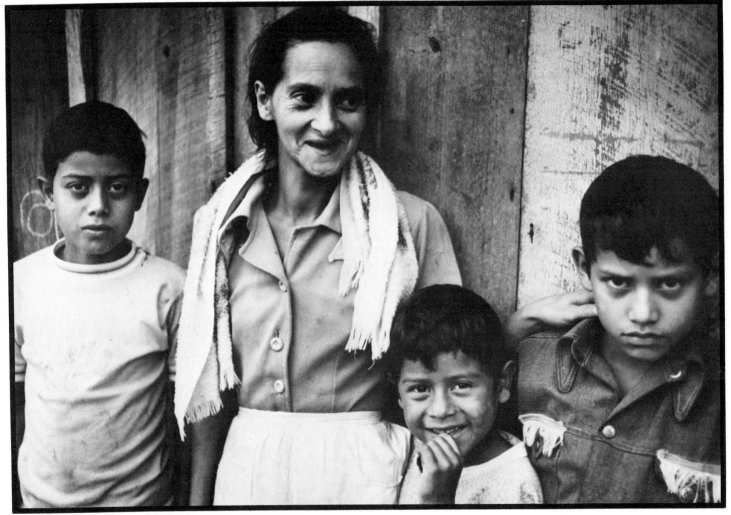

Peasant mother and her children, north of Estelí, Nicaragua.

The Nun

I would have died for you
but that was not allowed.

My father left me at the gate
as though I were an infant,
in a sack, without a name.
The sisters cut my hair.
They set my silks on fire.
In these black robes
I was born again.

Mornings in the damp church
stranded with women
as the sun strains
through the glass thighs
of the saints,
I pray for our child
as if she had my life
and for you also
who did what Christ
could not: persuade the judges
of your innocence.

—Helena Minton

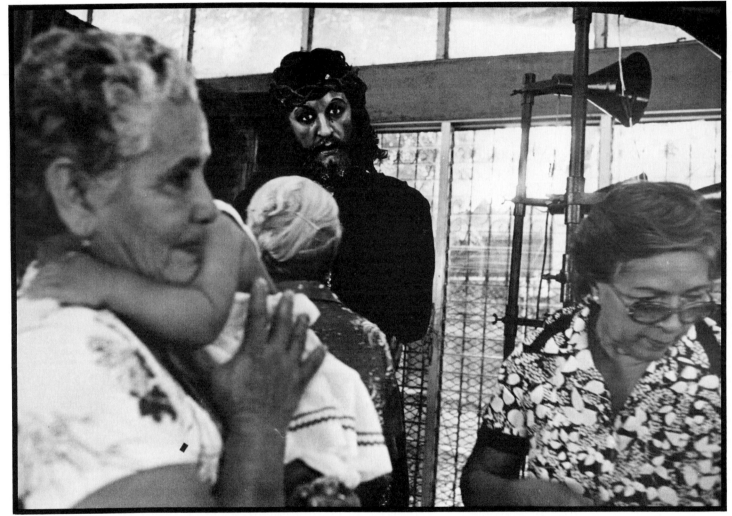

Women are the base of social change, within the Church and in society at large. The male death-like waxen larger than life image of a Christ figure is still there, though.

It's a hard life, a hard life. When the river rises
all the crops go down. And when it rains and
rains, then I'm afraid, I'm so afraid. My
animals go. Last night they took my duck;
over there you can see the female looking for
her mate. Yes, it's a hard life, not even enough
for a change of clothes. They operated on me
in Iquitos, because of the hemorrhage, they
took my months away. Now, when there's a
full moon, I feel crazy. Ay, there are times
when I feel like my head will die. They took
my months; I have no months anymore . . .

—Angela González, peasant woman in a
community on the Bajo Napo River,
Amazon Region, Peru.

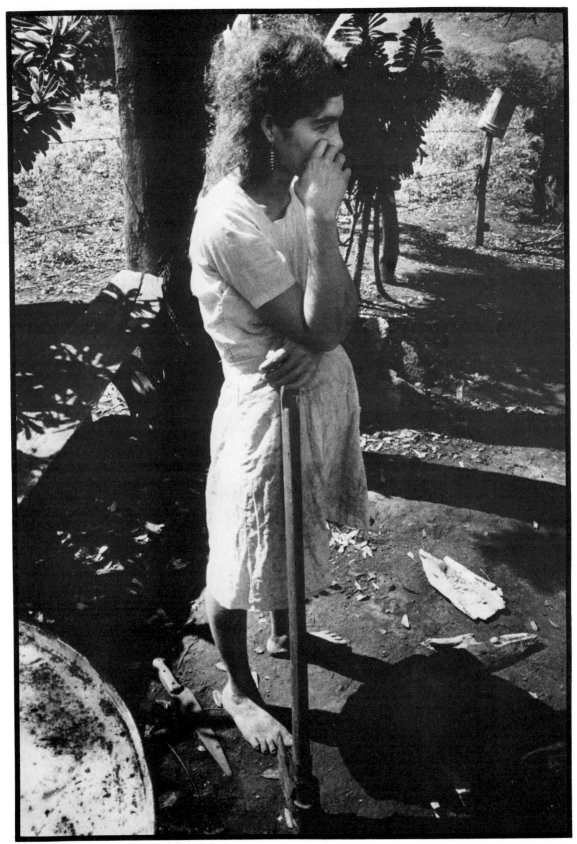

On the back roads around León, Nicaragua.

Obedience of the Corpse

The midwife puts a rag in the dead woman's hand,
Takes the hairpins out.

She smells apples,
Wonders where she keeps them in the house.
Nothing is under the sink
But a broken sack of potatoes
Growing eyes in the dark.

She hopes the mother's milk is good a while longer,
The woman up the road is still nursing—
But she remembers the neighbor
And the dead woman never got along.

A limb breaks,
She knows it's not the wind.
Somebody needs to set out some poison.

She looks to see if the woman wrote down any names,
Finds a white shirt to wrap the baby in.
It's beautiful she thinks—
Snow nobody has walked on.

 —D. Wright

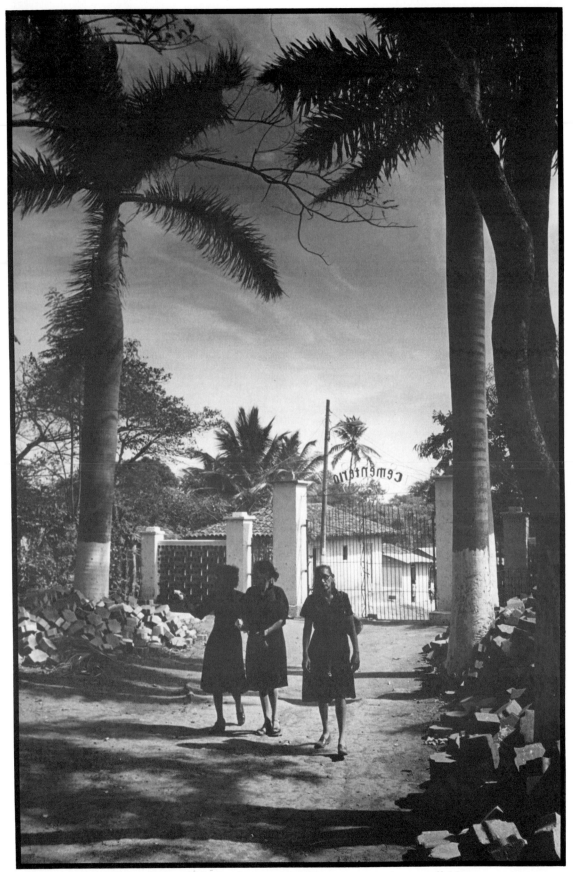

Three women in the traditional black of mourning visit a cemetery in a small Nicaraguan town.

My name is Martina the Beautiful, of Montesinos. I'm from right here—Huaro district—and I'm 58. My husband and I both work, he's from Cotabamba. After working in the fields, I tend to the selling: fruits, vegetables, and I make *chicha*. That helps us get by. I have five children, including an orphan boy I've raised. They're all in Lima, studying; the oldest supports them, he's a chauffeur . . . Sometimes I think I'm the only one who speaks out. Sometimes they tell me I talk 'cause I like to. "You're ahead of yourself," they say. "Only a few understand what you're talking about in the assemblies; the rest just laugh."

Most of the women just listen, they don't speak, and when I tell them the assemblies are for speaking, for getting what we need, they say their husbands are the ones who tell them not to say anything, not to get involved. I always tell the men they should bring their wives along, but they don't understand. They say: "Why should they come, if we're here?" But I think we should all participate, so we can all move forward. We have to give of ourselves, more and more. Like the Incas, long ago. They made a single force, united. And they rose as a single person. That's why they made such great works. Couldn't we do it too?

—Martina
Martina the Beautiful, community leader of Huaracondo, Peru, 1973.

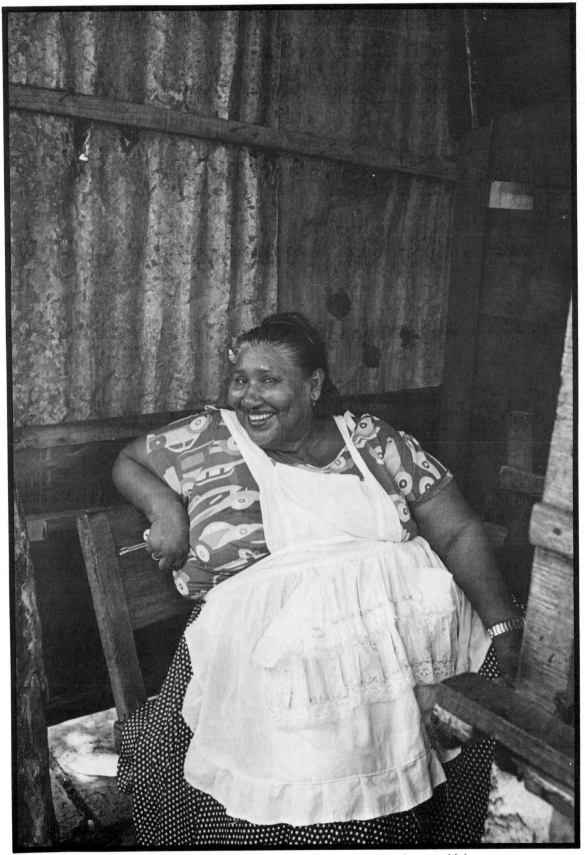

In Managua's Eastern Market, one woman is completely immersed in the joy of life.

Abel's Bride

Woman fears for man, he goes
out alone to his labors. No mirror
nests in his pocket. His face
opens and shuts with his hopes.
His sex hangs unhidden
or rises before him
blind and questioning.

She thinks herself
lucky. But sad. When she goes out
she looks in the glass, she remembers
herself. Stones, coal,
the hiss of water upon the kindled
branches—her being
is a cave, there are bones at the hearth.

—Denise Levertov

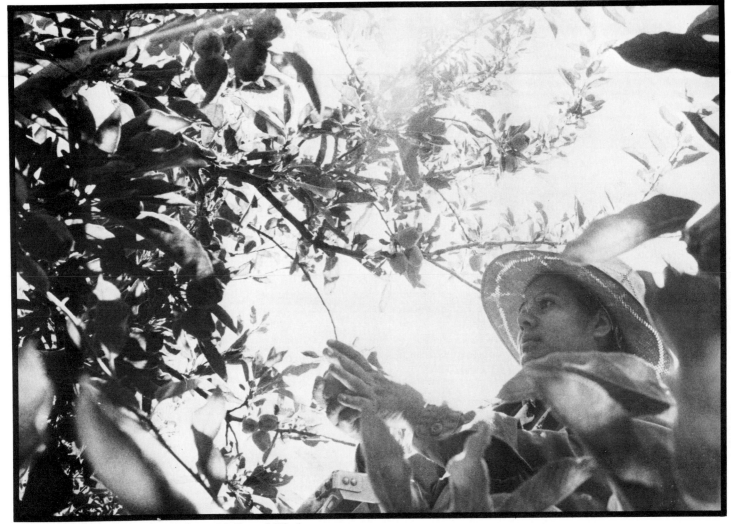

Thinning apple trees in the Yakima Valley of Washington state.

. . . My childhood . . . it was a little hard. My parents couldn't read or write. My mother's parents were Africans, slaves, and there were many things my mother didn't understand. But I understood them all right. Once, when I was little, I asked my mother—her name was Petrona and I called her Toñita—I asked her: "Why do we live so bad?" I'd ask her that question and she couldn't explain it to me. She'd tell me: "Ay, my daughter, that's just the way it is. One of these days the hens underneath are going to shit upwards!" Imagine, I was real little and I'd stand there looking at the hens' asses. And I'd say: "And when is that going to happen?" But now I know: it happened when we knocked the big ones down and raised the little ones up!

—Ismaela Acosta,
known as "Granma," tobacco worker
in Pinar del Río, Cuba.

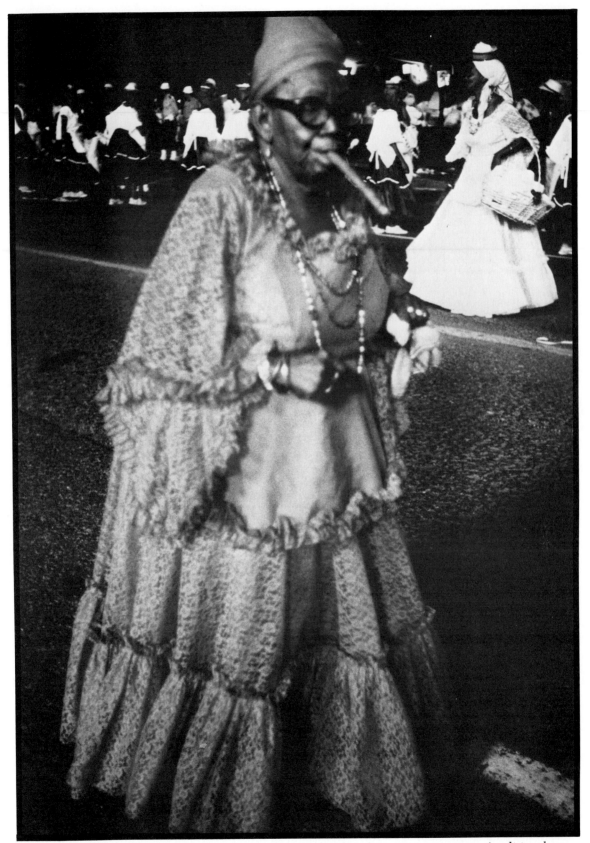

The wise woman, aged and with cigar in mouth, is a familiar figure in a comparsa (traditional carnival dance) in Havana, Cuba.

I'm a peasant woman. I was born in the hills, raised in the hills, married in the hills. We were three sisters, but there are only two of us left—one died in childbirth. I'm 36 and I've been married for 18 years. I've had nine children; but only four are living. Most of them died young, some at birth and others around the age of two. One died recently, in the war . . .

The life of a peasant woman wasn't easy. She got up at two in the morning to slap out the day's tortillas and to make the food she'd leave for her children. Then she went off to work in the fields alongside her man. She brought him his noonday meal. Perhaps only a bit of *pozol*—a ball of well-cooked cornmeal. Not much, in the way of nourishment. She had to help her husband plant the corn and the beans. The women went out to work in the fields with a machete or whatever they had. Often they'd have to leave their children locked in the house, leave food for them there—boiled beans with a little salt—and they just ate when they wanted. They were on their own. The older children helped their smaller brothers and sisters. It was a life of suffering, and the kids were sacrificed because that's just the way life was.

—Amada Pineda,
peasant woman and revolutionary leader, now a
member of Nicaragua's Agrarian Reform Court.

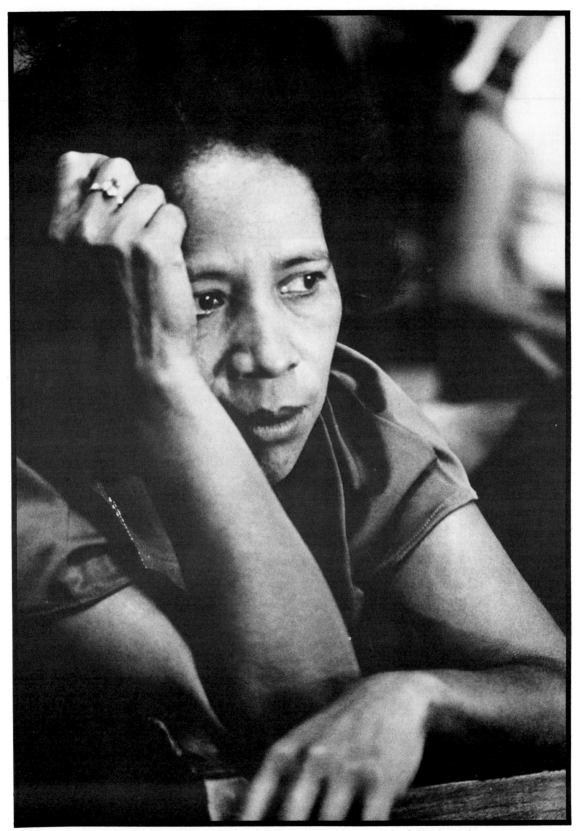

Nila Mendiola is one of the "Cuá women." These were women of the hills, brought to an anti-guerrilla camp by Somoza's troops in 1976. For refusing to divulge the whereabouts of the Sandinistas, their husbands were tortured to death and their bodies dropped from helicopters. The women were tortured and raped. One was 98 years old. Their story has been told in poetry and song in Nicaragua, and they are known—with admiration and love—as the "women of Cuá."

. . . In 1972 a large number of Chilean women, including women from sectors of the middle class, were used by the ruling class as a support base and as one of the springboards for the *coup d'etat*. Once the dictatorship took power, however, women were plunged into a paradoxical situation. On the one hand, the dictatorship has annihilated women socially, deprived them of the material and cultural means for survival, of their development as human beings, as workers; and on the other hand, by burying women under decrees and decisions which have progressively isolated them, thrusting them with even greater force back into their traditional roles. They are filled with hatred— hatred which bit by bit will become power and decision. The dictatorship forces women to leave their homes in search of food, to fulfill a more important role in the economy of the home. Women once again have become the center of the family, as they were a thousand years ago, because their mates have been imprisoned, disappeared, assassinated, or are unemployed or earning the minimum wage . . .

And on going out to look for work, to wash clothes in the houses of the rich, to beg for charity in the parish or neighborhood, Chilean working women leave the ghetto, enrich their view of what is happening, and achieve primary, or at times diffuse, forms of consciousness. They become restless, they ask questions, they find answers on their own, or they seek them from other women . . .

—Gladys Díaz,
Chilean revolutionary leader, from "Collective Reflections of a Group of Militant Prisoners," first presented in Venezuela in 1979.

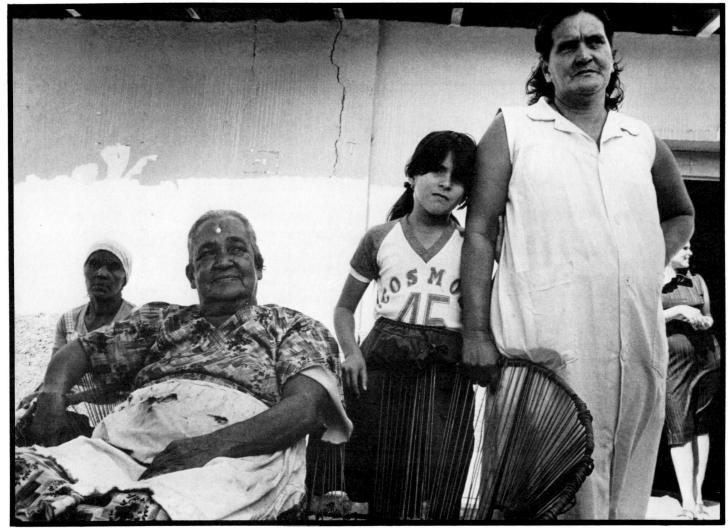

This family lives in San Pedro Norte, village on the Nicaraguan/Honduran border, an area frequently shelled by "contra" forces.

My husband and I had been separated for quite a while. He was fighting in Managua, and then he took part in the retreat to Masaya. When we saw each other on July 21st, we both cried. *We had won!* Before, when we talked about what it would be like, I'd tell him that the best thing that could happen would be if we both came out alive, so we could tell each other where we'd been, what we'd done. And that's exactly what happened. He told me about his experiences, and I told him about mine, because I fought too . . .

—Julia García, 26 years old, Managua, Nicaragua.

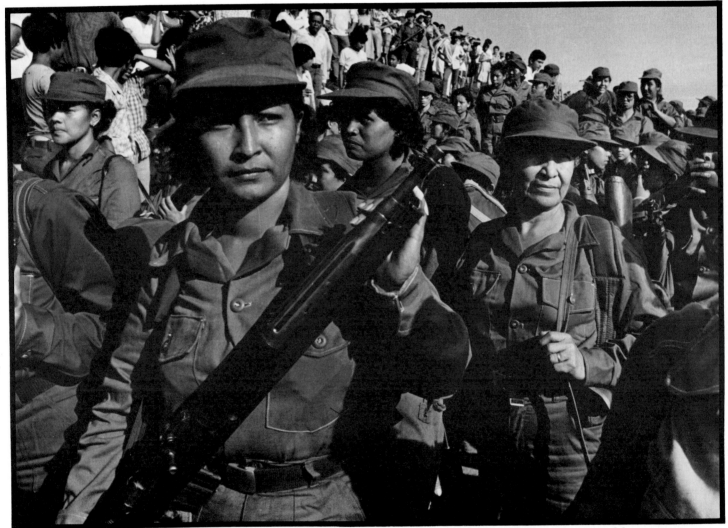

The "Erlinda López" women's battalion prepares to go off for several weeks of mountain training. Managua, Nicaragua.

I was the only woman in the guerilla column. There were those who expected me to leave. Many of the comrades still weren't used to having a woman in the column. Sometimes they'd joke around, and ask why I hadn't stayed where I belonged, in the city. Or they'd tell me I was slowing the guerrilla down. So when Carlos gave us that ultimatum, some of the comrades looked at me as if to say: "Go on, leave." But I reminded myself that I'd come to stay, and they had no right to intimidate me.

No one made a move. Everyone just stood there, waiting out the half hour. And once it was over, Carlos began to cry. It was the first and only time I ever saw him cry. Then the kidding began. We punched and hugged each other. And everyone laughed. We acted like a bunch of kids. Carlos and Silvio spoke at once, then. They said they knew all along that no one had thought of leaving, neither I nor anyone else.

—Gladys Báez, Nicaraguan revolutionary leader.

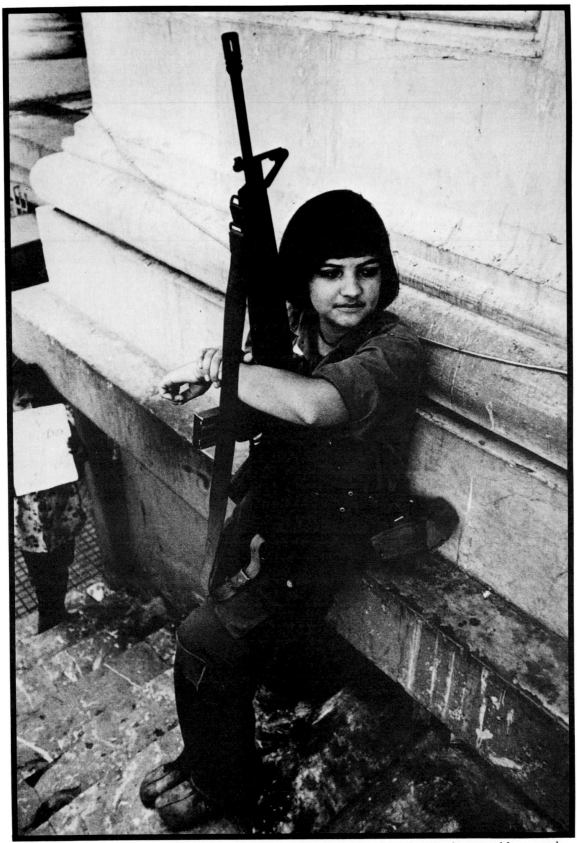

The Sandinistas were young: seventeen, fourteen, even nine years old. This Sandinista soldier guards the National Palace in November of 1979, only a few months after the people's victory. She is sixteen.

It was through my example that my children got involved, one by one. My oldest son Edgar was killed near the end of the war. I feel the satisfaction of my son's having given his life to our country, though it isn't easy for me to say that now. Someday it will be easier, I'm sure. But now the wound is still too raw. I love our revolution deeply. You can't imagine how deeply. I was willing to give my own life for our freedom, and now I'm doubly committed; besides being ready to give my own life, I've also sacrificed my son's.

—Mercedes Taleno, Nicaraguan working woman and mother, Managua.

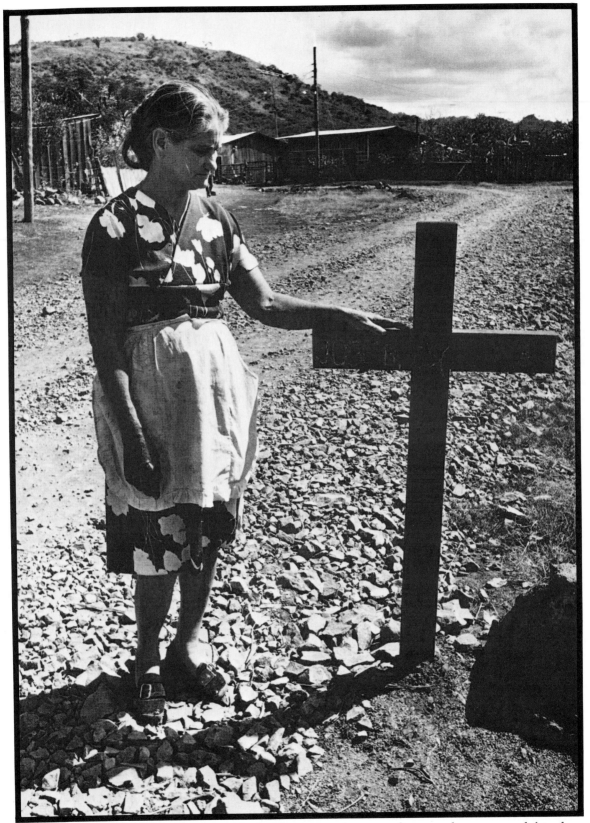

There were 50,000 dead. A woman in Estelí, Nicaragua, shows me the spot where a mutual friend died. Her home had been his safe house during the last few weeks of his life.

Two Versions of Inés

I'd been in El Salvador two weeks and I was walking home one day when I heard shots. There were tanks all along the block, and some fifty soldiers and police. They had mortars, machine guns, and they were attacking one house in particular. It was incredible, because they had all this trained on just one house, and the only thing you could hear coming from inside the house were the shots of a small calibre pistol. Then the shots from inside were heard no more. Everything grew quiet. The smoke cleared and the first group of policemen and journalists entered the house. There was a young man dead in the bathroom. And there was a woman, maybe forty or forty-five, wearing an apron and with a kerchief around her head. She was lying in a pool of blood . . . I was the only woman in the group, and the only journalist from the U.S. who had stayed in El Salvador for more than a couple of days that month. And I just couldn't believe what happened next: the Chief of Police went into another room and got a machine gun. He knelt beside the older woman and placed it in her hand. "This was the weapon, this was the machine gun she used against us," he said. He got a box of bullets, unused bullets still wrapped in paper, and he threw them on the floor on top of her blood. "Those were her bullets," he said. And the international press took photos and they said, "Right, right," and they took notes: ". . . she had a machine gun, she was shooting at the Government Forces . . . terrorist, guerrilla" and so on.

—Ann Nelson, U.S. journalist.

There were three comrades. The house was surrounded. They had tanks, even helicopters. In spite of it being such an unequal situation, the battle lasted half a day, until they reduced the house to ashes. They were frightened to go in before that. The most beautiful thing, the lesson, was what they found when they did go in: Inés, dead in a pool of blood. With her own blood, before she died, she had written FLP on the wall. It was a battle that made an impression on everyone in the capital.

—Commandante Ana María

On Santamaria Beach in Cuba.

I'd say what's happened with women is the greatest thing that's happened in this Revolution. Look at me — and like me there are thousands and thousands — women who have been liberated economically, politically, in every way. Look at my case: I got married like all women here got married, well, because I loved the man and all that, but basically to free myself from my family, my home, find someone who would support me. Now look at my daughter: my daughter is fourteen, and when I was fourteen I didn't even dare look out the window. And my daughter goes everywhere by herself! My daughter talks about things you couldn't even mention in my house when I was her age! And if this revolution hadn't triumphed, I'd still be a housewife: miserable, without any kind of future, without opportunities of any kind, laden down with kids, totally miserable! That was the destiny of our people, of our women. And that isn't the Cuban woman anymore. That kind of tradition has seen its day in Cuba!

— Teresa Sánchez, member of the National Executive Board of the Revolutionary Defense Committees, Havana, Cuba.

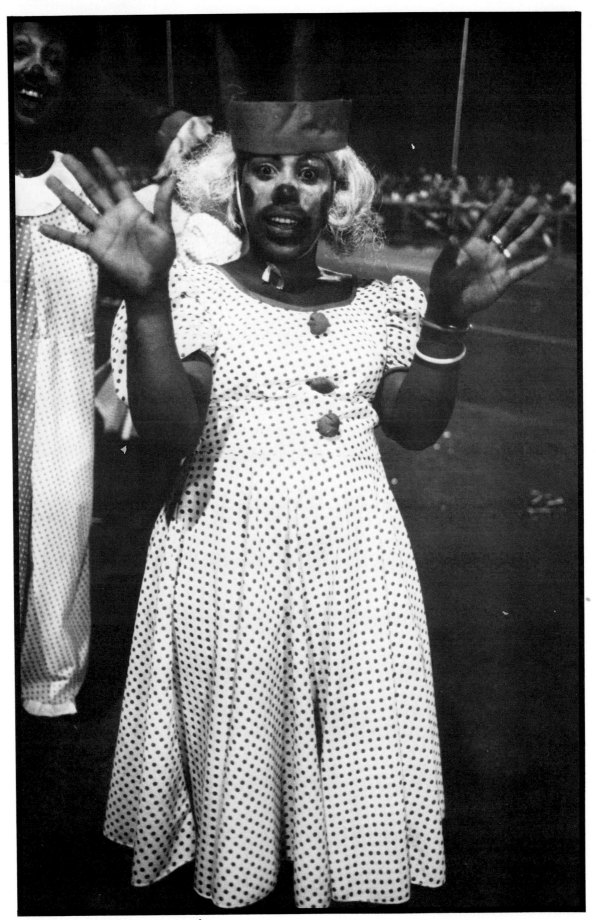

A clown during Havana carnival.

Theatre has been essential in the development of our community, and in our own development as women. Just in terms of women's incorporation into the labor force, to give one example, theatre has played a tremendous role. At the beginning there were only six of us women working in production here at Jibacoa. Today eighty-six percent of our women are working. We owe this, in great measure, to our theatre.

Our experience with the play about sexism was tremendous. We criticized the man who thinks his wife is a submissive object, something to be kept at home, and we showed how women can't and mustn't accept that kind of attitude. We dramatized cases we have right here in the community, so we could debate them later with the audience, right here with those directly affected. "What do you think of so-and-so, who won't let his wife work?" we asked. And then came the opinions: "He's an egotist . . . he's wrong . . . this community was built so that everyone, men and women, can have the same opportunities."

—Jacinta Odilia Orozco, worker and member of the theatre group, Jibacoa agricultural community, Havana Province, Cuba.

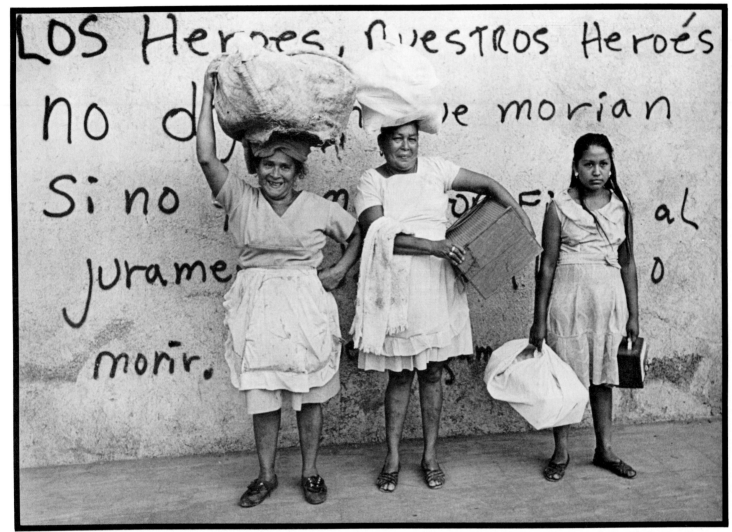

The writing on the wall is by Nicaraguan poet-martyr Leonel Rugama. "The heroes, our heroes, never said they'd die for their country. They just died . . ." Rugama was twenty years old when the house he was hiding in was surrounded and he was murdered by four hundred national guardsmen in January of 1970.

My grandmother came from the old country
her father was a Rabbi so she went to school
 learned to read
 and married the man of her choice

in the countryside of Russia she ran barefoot in the grass
that's all she told me about it
"that's in the past," she said, "look to the future"

The generation of my grandparents
traveled the length of Europe
then the Atlantic ocean
and now those that remain live in long narrow hallways
and small dark airless rooms
sitting
they watch their bodies die around them
and wait

In the old days
when a person's hands grew stiff and feet swelled up
and they couldn't remember their daughter-in-law's name
they died
but today a person should live as long as possible
"I have lived long enough," she said
"Oh no!" they said, "don't say things like that!". . .

 —Fran Baskin

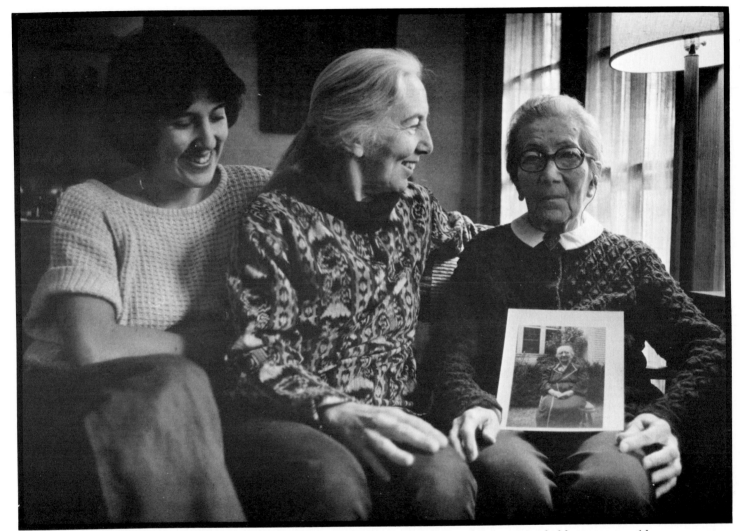

In Boston, Debbie is daughter of Ruth, Ruth is daughter of Hella, and Hella—in her nineties—holds a picture of her own mother, Anna, now gone.

The Girl Who Turned into Cider

Jorge, Eduardo, Ernesto, Alfred, Alberto, ooh, and so many more, I have twenty-seven sweethearts and one apple tree. And I want that to last forever: the red fruit. It makes it so easy. I call to a boy, I give him an apple and at the same time I ask him, do you want to be my sweetheart? If he says no, I take back the apple even if he's already had a bite (I usually throw those in the trash). But if he says yes, oh, what happiness, right away I put down a new name on my list. I try whenever possible to have all different names: it's a good collection, I don't want to spoil it by repeating myself. I give them the apple and it makes them thirsty and then they can't get enough. Then they ask me for a proof of my love to seal the pact and I'm not one to say no.

It's the most wonderful feeling, little by little I feel everything inside me fermenting. It tickles. As time passes—and the boys—I am more and more aware of a sweet odor coming from inside me, the perfume of apples, and my apple tree keeps bearing its fruit and boys come now from far away to ask me for them. First they have to eat the apple—they know that—if not they're not my sweethearts. Then we roll around a while in the high grass behind my house and each time I feel a little more liquid in their arms, effervescent and pale.

That's why I ordered a big barrel, in case one day I feel I want to withdraw and complete the process. Could I go on without them, without my sweethearts? And the second question, do I truly want to change so much? I would rather just go on giving out my apples, but that's the problem: you know what happens when you give, but you can't be sure what may happen when you get something in exchange.

—Luisa Valenzuela

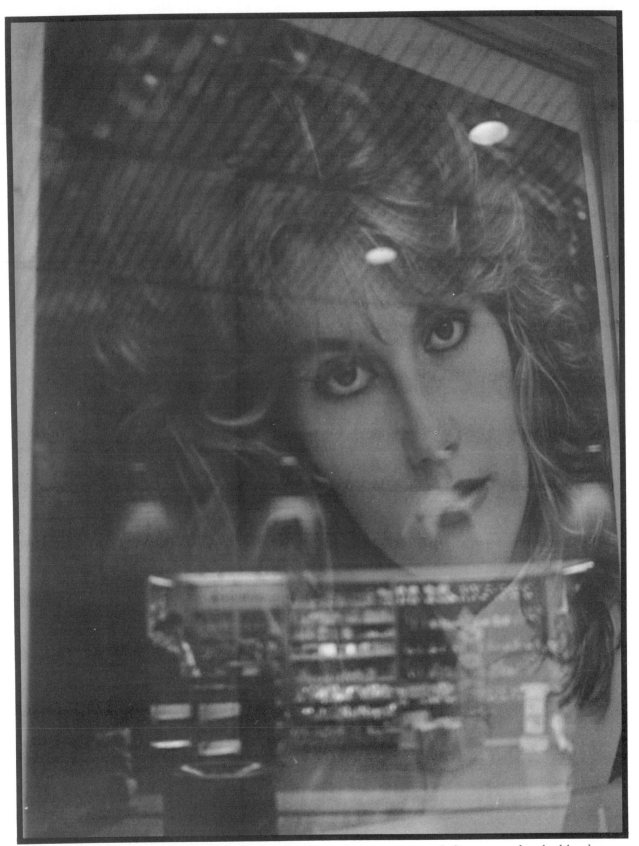

We are reflected, as they wish us to feel we need to be, and so we start out feeling we need to be like that. Like this. Eaton Centre, Toronto, Canada.

In the Middle of the Night

I woke him up to tell him my dream:
no table, no pitcher to prop them—
white bouganvillas, disconnected from the dark.
Not gleaming, not fragrant or pure,
just white on the branch, fat white milk.
In the dark room, one vividness: the peculiar act of seeing.
The way you recognize a flavor, I felt what they were saying—
"A resurrection is already being woven, tubers of joy
which will burst into bells."
It hurt like pleasure.
He saw I wasn't lying and said:
"Women are so complicated, men so simple.
I'm simple. You could be too."
I'd like to be simple, right now—
simple, simple, I began repeating—simple.
Suddenly the word stood out
like the bouganvillas in the dream. It knocked me over.
"What's wrong?" he asked.
—The bouganvillas—
We couldn't get any further than that,
so I sobbed out loud, weeping, weeping,
until I became simple enough to fall back to sleep.

—Adelía Prado

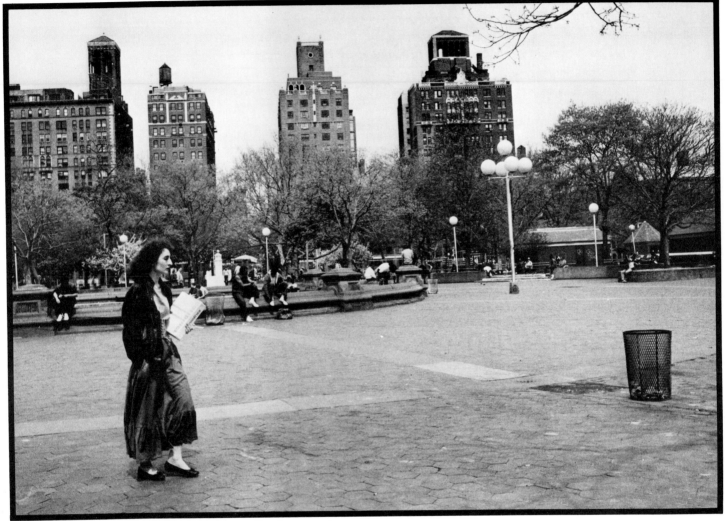

Manhattan's Washington Square Park on a Sunday morning.

After All Is Said and Done

Maybe you thought I would forget
about the sunrise
how the moon stayed in the morning
time a lower lip
your partly open partly spoken
mouth

Maybe you thought I would exaggerate
the fire of the stars
the fire of the wet wood burning by
the waterside
the fire of the fuck the sudden move
you made me make
to meet you
(fire)

BABY
I do not exaggerate and
if
I could
I would.

—June Jordan

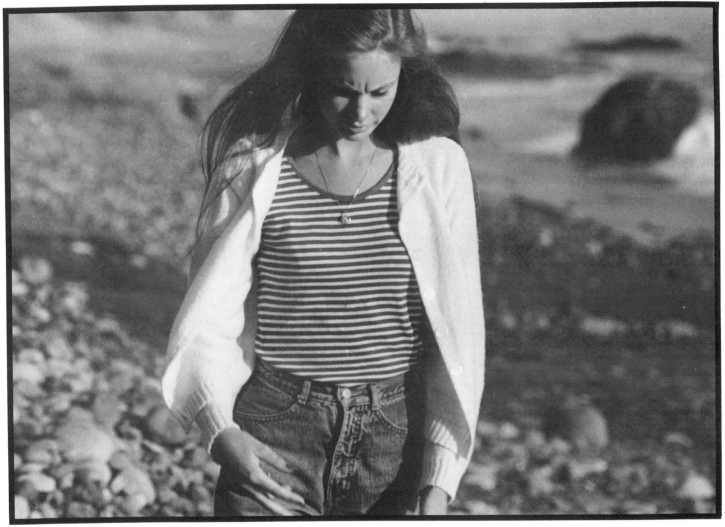

The beach at San Simeon, California.

O Pioneers

When you are being brave
It is hard to feel

When you are exhausted

The letdown usually comes
At the end of the journey, the wheels
Stop turning

Sand buckets rust on the beach
Mold gathers in the closets

After 2 thousand 7 hundred miles
In the August heat a dead house

Waits for you, your fat legs
Swell up and the garbage
Disposal won't work

—O Pioneers
(Someone is always saying)

Where have they all gone,
The courage, the stamina, the guts—

Sliding up the driveway
No more mindless

Exhilaration bulk of the soil,
The pure tug of the muscles:

Just as you're opening the front door
The phone rings, it's the boss
In stale air

Over smooth plastic he tells your husband
You're late, where have you been,

Out of the corner of your eye you catch him
Blurred, red-faced, jittering
Smiling desperately, in one place

Overdue bills like arrows
Pile up on the front lawn,

Delivery vans circle the house, well
CERTAINLY IT'S OKAY

To turn up the air conditioner,
Lie down, take a tranquilizer,

When you are exhausted of course it is hard to feel
Anything real, all of you

Please,
Don't be ashamed.

—Patricia Goedicke

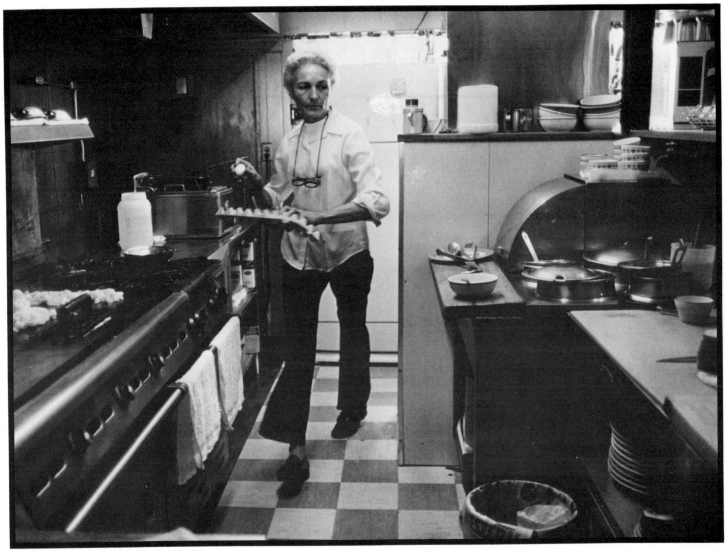

At a truck stop in Petaluma, California.

Nuestro Dolor

Labor Day. All over Aztlán
the midwives are polishing
their instrumental silver hands.
The full moon
isn't until day after tomorrow,
but already the fat milky body
is heaving, sweating,
rolling over and crushing us
in its desperation to deliver
itself of its monthly sorrow.
Workers hungry in the fields,
drunks on lopsided street corners,
old ladies shuffling off to church
on over-sugared legs,
boys lost in poison whiffs
of high heaven.
Ours are the tears that rub
the moon's bloated belly.
We are this child's family.
Where else will it come,
with its little harelip of blood,
but to us?

—Rosemary Catacalos

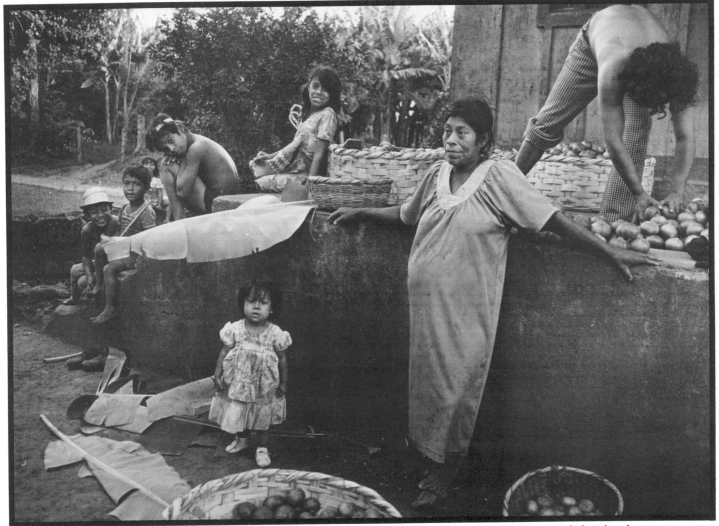

She told me she had twelve children, and was expecting another. They collected fruit, and sold it. And they lived in a one-room abandoned train depot, along tracks long since forgotten, in rural Nicaragua.

Rape Poem

There is no difference between being raped
and being pushed down a flight of cement steps
except that the wounds also bleed inside.

There is no difference between being raped
and being run over by a truck
except that afterward men ask if you enjoyed it.

There is no difference between being raped
and being bit on the ankle by a rattlesnake
except that people ask if your skirt was short
and why you were out alone anyhow.

There is no difference between being raped
and going head first through a windshield
except that afterward you are afraid
not of cars
but half the human race.

The rapist is your boyfriend's brother.
He sits beside you in the movies eating popcorn.
Rape fattens on the fantasies of the normal male
like a maggot in garbage.

Fear of rape is a cold wind blowing
all of the time on a woman's hunched back.
Never to stroll alone on a sand road through pine woods,
never to climb a trail across a bald mountain
without that aluminum in the mouth
when I see a man climbing toward me.

Never to open the door to a knock
without that razor just grazing the throat.
The fear of the dark side of hedges,
the back seat of a car, the empty house
rattling keys like a snake's warning.
The fear of the smiling man
in whose pocket is a knife.
The fear of the serious man
in whose fist is locked hatred.

All it takes to cast a rapist is to be able to see your body
as jackhammer, as blowtorch, as adding-machine-gun.
All it takes is hating that body
your own, your self, your muscle that softens to flab.

All it takes is to push what you hate,
what you fear onto the soft alien flesh.
To bucket out invincible as a tank
armored with threads without senses
to possess and punish in one act,
to rip up leisure, to murder those who dare
live in the leafy flesh open to love.

—Marge Piercy

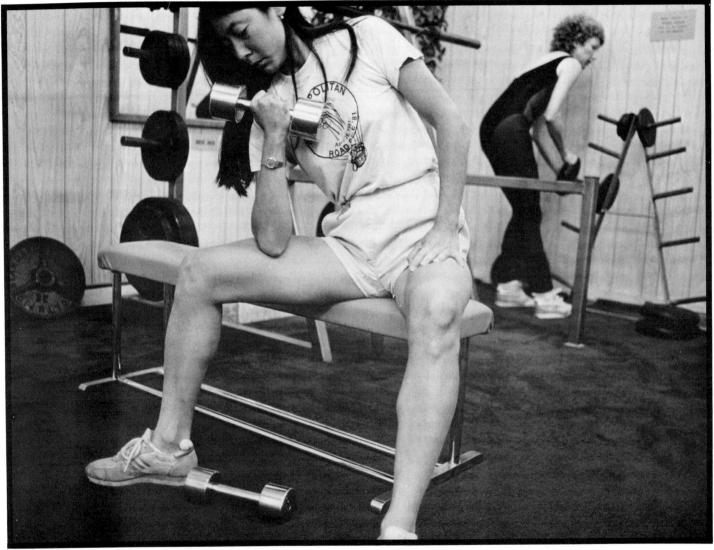

Lynn lifts weights at a gym in Berkeley, California.

August 29, 1979
Sonoma County Jail

Dear Ladies,

. . . My husband and I were married four years before his death. My husband beat me, dominated me, and almost killed me on several occasions. I left him four times. Then he would find me. It seemed like there was nowhere I could go to be safe. I felt there was no one I could tell what was happening to me, for fear he would find out and kill me or hurt them. I was trapped.

One night my whole life was changed by the pull of a trigger. My husband had beat me at a wedding reception. He had choked me, poured whiskey on me, and told people he was going to kill me. He had done all this before, over and over again, but this night was different, he was more dominant than I had ever known him to be.

I went through a living hell, which I assumed no one could ever understand. To make a long story short, I shot and killed my husband that night, and I want you to know I'm going through more hell now than you could ever imagine. Between living with the fact that I took a life, and going through the hell of a trial, the newspapers, and the worst hell of all, going to prison.

There are many other horrible trials for me to face. I hope and pray that this will touch someone out there. I know there are many women in this world who are going through the same living hell I went through. I cannot stress how my heart cries for you. Please, from one who knows, get away and stay away no matter how it hurts you, because life in jail and prison is no life at all . . .

Respectfully,

Audra I. Giarritta (signed),
California woman in jail for shooting her husband
after years of battering.

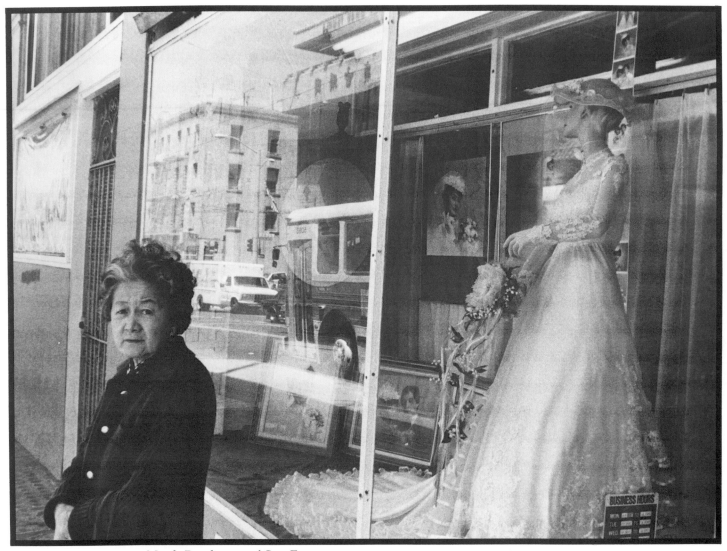

The reflection again . . . North Beach area of San Francisco.

. . . When we were very little our fathers always taught us that we must remain faithful to our ancestors, to our culture and to our traditions . . . Before planting we have to ask permission from the earth to do it this injury; we have the right to injure it only for food . . . Pregnant women, during the time they are with child, must tell the child they're carrying everything they see when they're walking through the woods . . . I was and am an ardent *Catequista.* In the community we began to reflect together about what the Bible told us. The story of Judith, for example, impressed me a great deal; she cut off the head of the king in order to save her people . . .

It was my mother, going from village to village, who became acquainted with the guerrillas. When all she could wish for was to die, the army commandant ordered them to force serum into her and give her food to eat. They revived her, and when she recovered her strength, they began torturing her again. A human being can withstand many things, but resistance has its limits. My mother's agony began again. They put her under a tree, right in the middle of a field, and using a fly we have which immediately lays eggs when you put it on a wound, they filled her body with worms . . . She struggled a long time and then died under the sun and in the cold. They didn't even let us have her body. The soldiers stayed until the buzzards and the dogs had eaten her . . . We, her children, we her orphans, had to find another way of fighting . . .

—Rigoberta Menchú
Testimony of Rigoberta Menchú, Quinché Indian woman of
Guatemala, member of her country's revolutionary movement.

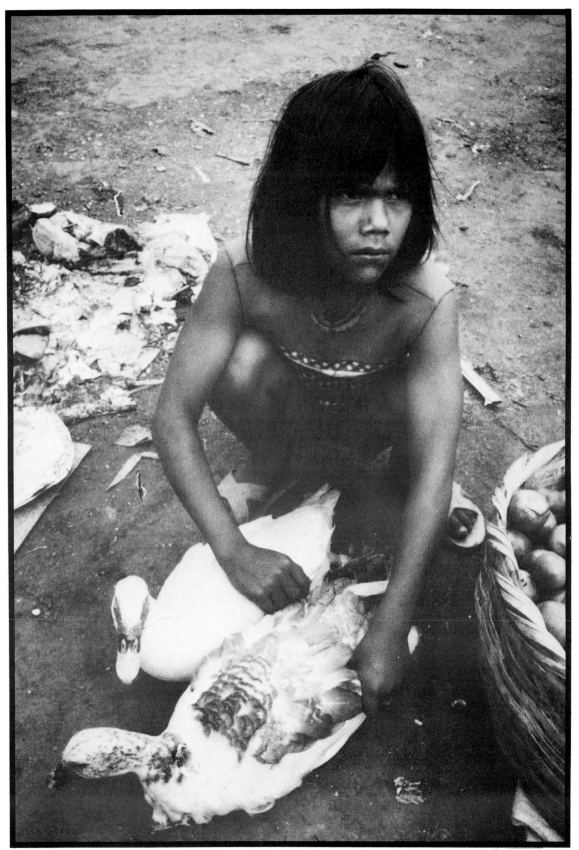

Young girls become women early in Latin America. This twelve-year-old sells fowl in Managua's Eastern Market.

I didn't think it would be like that, when I first arrived I didn't think that's what it would be like. I didn't know about eating different, like they ate meat and salad (the family), and they gave us meat too but in a stew, different from theirs. Different from what they ate. That separation of the food . . . for instance, they ate cake and we didn't, they ate sweets but they never gave any to us. And then the rooms way up there on the roof. For me that was a shock, because in Pisco the maids' rooms are inside; only the new houses, the ones they're building now, they have the maids' rooms on the roof. I felt alone . . .

—Soledad, a maid in Lima, Peru,
speaks of arriving in the city.

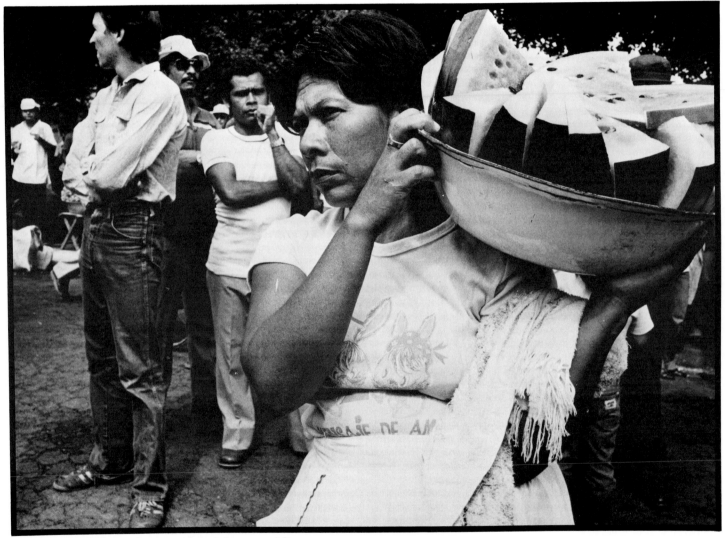

Woman selling slices of watermelon, Managua, Nicaragua.

Leaving

Four o'clock this morning there was a call.
She talked Indian, so it was probably her mother.
It was. Something not too drastic, tone of voice,
no deaths or car wrecks. But something. I was
out of the sheets, unwrapped from the blankets,
fighting to stay in sleep. Slipped in and out of her
voice, her voice on the line.
She came back to me. Lit cigarette blurred in the dark.
All lights off but that. Laid
down next to me, empty, these final hours
before my leaving.

Her sister was running away from her boyfriend and
was stranded in Calgary, Alberta. Needed money
and comfort for the long return back home.

I dreamed of a Canadian plain, and warm arms around me,
the soft skin of the body's landscape. And I dreamed of bear,
and a thousand mile escape homeward.

—Joy Harjo

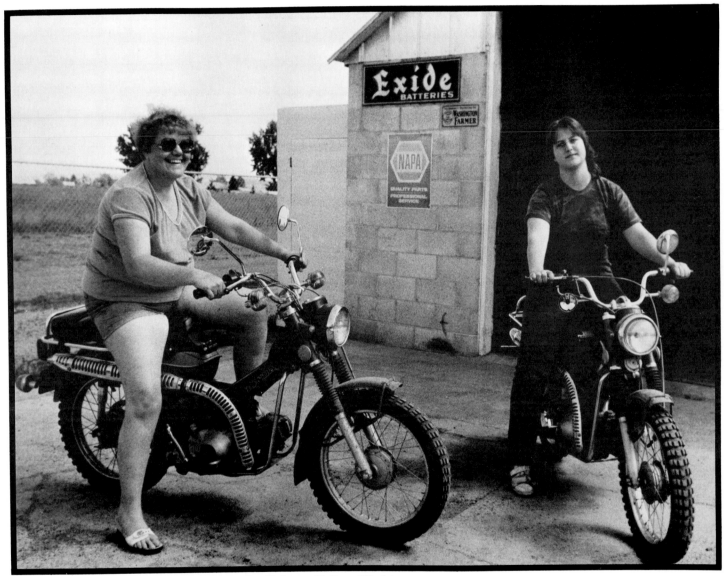

Sue and Angela, mother and daughter, in the Yakima Valley, Washington.

Evelyn Searching (to my sister evelyn)

Could i tell you how it is
to search the vacant faces
like lockers at a bus station,

to spend three days and two nights
waiting for the right time
to say father or even sister?

would it even matter if i said
the looking and the finding
could split you in two
send you into empty caverns
of silence fearful of the
sound of your own voice?

I can stand long and far
from that punishing storm
and see in you how strangers
become fathers become strangers
in time and of choice
and how we return and we will
as daughters
as mothers lifting the children
above our heads
to change the color of the sky.

—Denise Penek

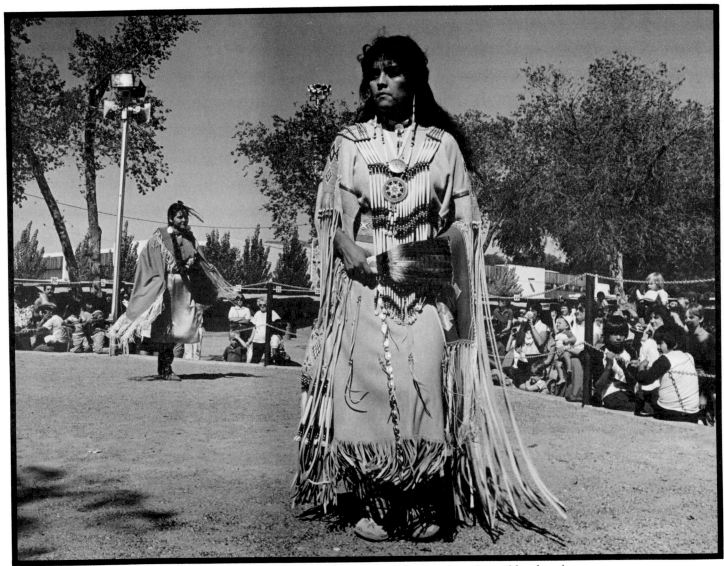

She dances at the State Fair in Albuquerque. She moves slowly, as if she hears another, older drumbeat.

Woman:
unfinished being
not the remote angelical rose sung by poets of old
nor the sinister witch burned at Inquisition's stake
nor the lauded and desired prostitute
nor the blessed mother.
Neither the withering, taunted old maid
nor she who is obliged to be beautiful.
Nor she who is obliged to be bad
nor she who lives because they let her.
Not she who must always say yes.
Woman, a being who begins to know who she is
and starts to live . . .

—Alaide Foppa, Guatemalan poet, feminist and ac-
tivist who lived in Mexico for many years. In
December of 1980 she returned to Guatemala to
visit her elderly mother, and disappeared, never to
be heard from since.

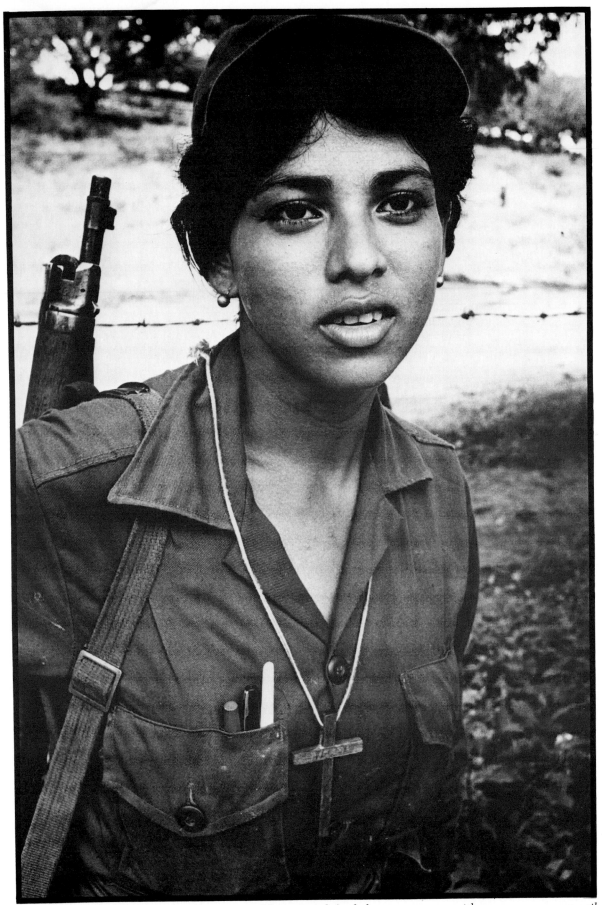

"Somewhere in Nicaragua" this sixteen-year-old woman defends her country . . . *with a gun, a cross, a nail file, and a pen.*

The foreman came in and he said, "The war's over," and everybody stopped work and gathered around him you know, to hear the news. They just kept standing around, and I had a pipe going in my booth, and I decided that I'd go back and work on my pipe. So then the boss, he comes over and he says, "Shorty, what are you doing working on that pipe?" He says, "You can do that tomorrow," he says. "The war's over and there's no hurry now." He says, "Nobody's working but you." And I said, "Well, I want to finish this pipe." I said, "This is the last pipe I'll ever weld." And he laughed, you know, and he said, "Oh, you're kidding, Shorty." He said, "You'll be here tomorrow." I said, "You want to bet?" He walked away, and I went ahead and finished my pipe, and that was the last pipe I welded. They laid me off the next day. The women in the pipe shop were all laid off.

—Edna Hopkins

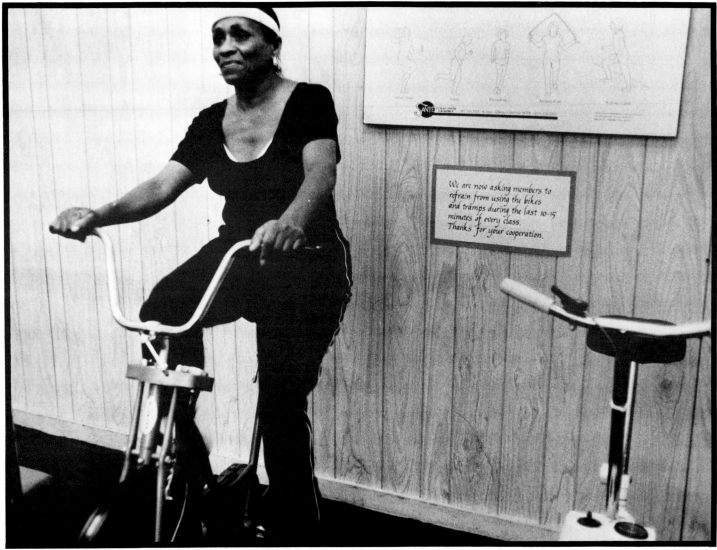

Lorraine works out at a gym in Berkeley, California.

I'm telling you, it's something to cry about. And it's not something I'd tell just anyone. Around ten at night everyone went to bed. And the lady of the house would say: "Wait up, the Mister is coming, so you can fix him his dinner." (The Mister was her son, he was 45 and he never married.) And I waited up, every night. He'd come home drunk. He'd come around midnight and he'd come to the kitchen where I was waiting, and he'd try to grab me and kiss me. I threw the soup ladle at him. And I'd cry and I'd tell him: if you try that again, I don't know what I'll do! He never managed to do anything, really, because I always defended myself. But when I told the lady of the house I wanted to leave, she told me: "You're not going anywhere; you came with papers."

—Margarita, a maid in Lima, Peru.

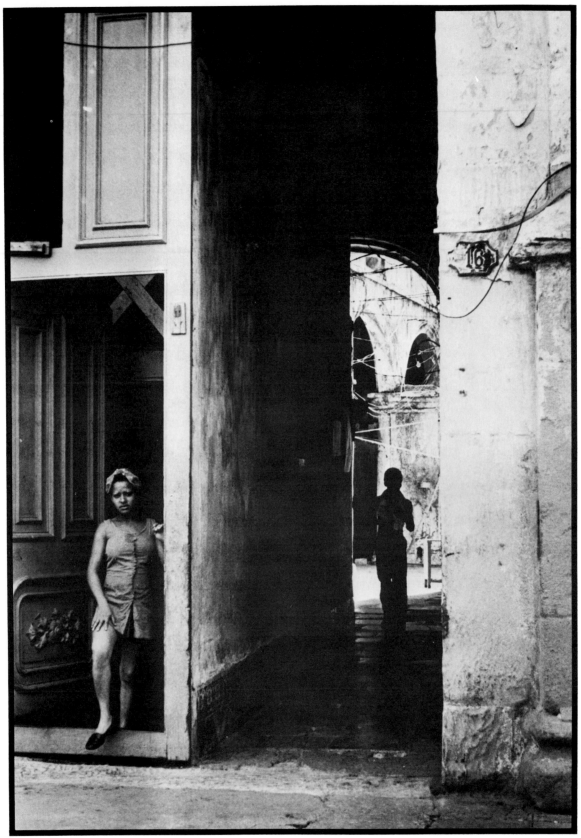

In the old part of Havana, Cuba.

(The other women) they were more or less sitting back and watching you, you know, to see what you were gonna do. You might have asked some things — and then they wanted to see how you'd come off, personality wise, or whatever. And I would talk. When you're going on a new job, you know, you're very, very scared, and especially in a steel plant, you're scared of everything, anything that passed you by. So you tend to sometimes try too hard, or you may be too friendly, or ask too many questions. And then you're dealing with a lot of people and their personalities. Everybody are not talkers, and everybody are not open, so you find the ones that you can talk to, that are drawn to you, and in the end they will be the ones to clear the way for you.

—Doris McKinney
Fragment from a long interview with a
Buffalo ex-steel worker.

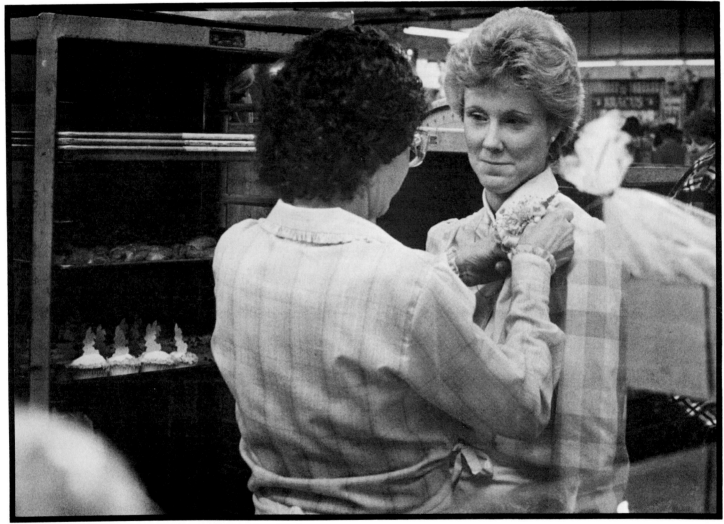

Easter time in a Polish market in Buffalo, New York.

. . . The manager asked me: "How many people want to work?" "Two hundred," I told him. "Well, we can hire all two hundred . . .". The girls with whom we'd begun looking for work all stayed on. None of them walked out on the group. They began to work. Every day they'd get home really bushed, with their hands very sore. Because they had to do everything by hand. Their hands would be bleeding. They were paid 400 *pesos* and they worked like that for a month, till they were laid off. Wow! They thought that was heaven!

—Domitila Barrios de Chungara, community organizer and wife of a tin miner, Siglo XX Mine, Bolivia.

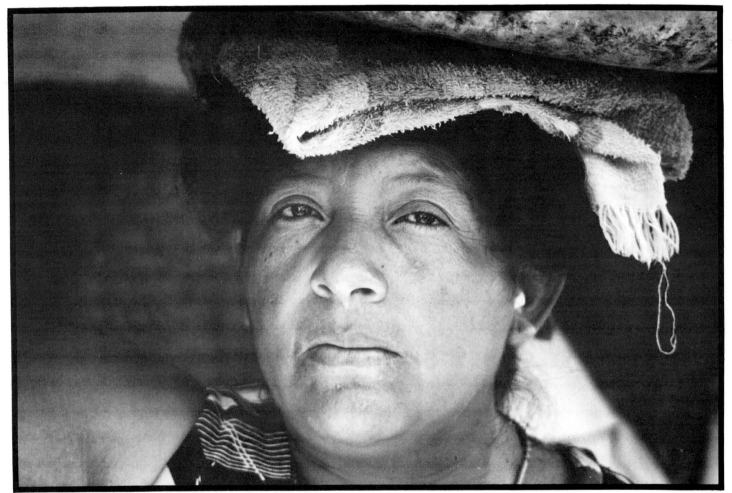

In a religious procession in Masaya, Nicaragua, she carried a large pan of sweets which she sold, balanced on the conventional towels on her head.

Puerto Rico is famous for its embroidery, real fine work, and you get that there like you do in other "underdeveloped" countries because the workers are practically slaves. You don't know what that work's like. We worked by the light of a kerosene lamp until two in the morning, day after day, night after night. And with little enough to eat . . . You just worked and worked with the needle. Needle factories, they called them. That's what I was doing, working in Mayaguez, when Albizu Campos began preaching . . .

At that time I didn't have—didn't have, no. I didn't know. I didn't know what the class struggle was all about. I didn't understand class struggle, but I sure did understand misery.

—Dominga de la Cruz, Puerto Rican Nationalist

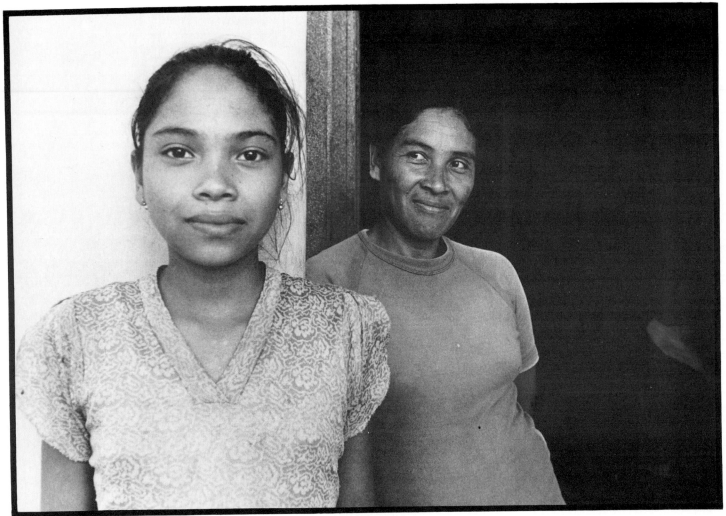

Mother and daughter, San Pedro Norte, Nicaraguan-Honduran border.

A typical workday was getting up at six o'clock in the morning, fixing breakfast, taking the baby to the Fruit and Flower Mission, catching the bus, getting out to Oregon Ship, welding eight hours, dashing home, Papa'd pick up the baby, I'd get cleaned up and take off for my waitress job at Nendel's and he'd take care of the baby, then I'd come home at midnight and wash out the diapers and hang 'em out.

—Lue Rayne Culberton, shipyard worker

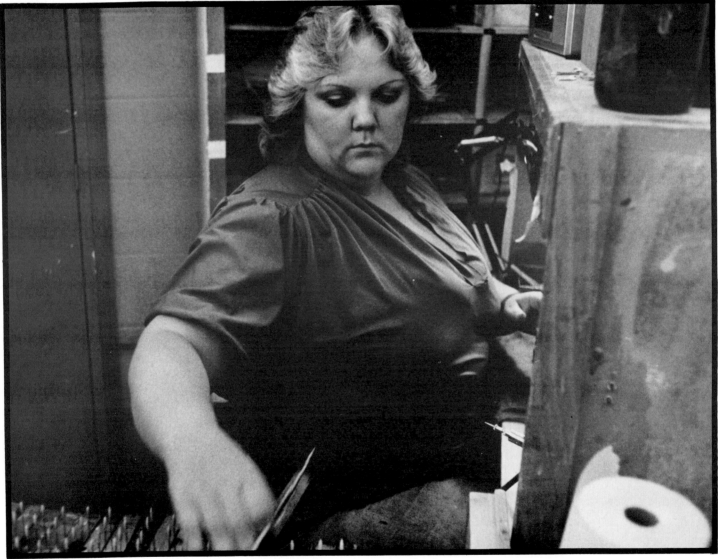
Worker in a bait factory in Yakima Valley, Washington.

Never before have we fought like this! For us this is still the most significant and the strongest-ever experience of struggle. When we started we really didn't know what we were getting into. We didn't know how to conduct a meeting, let alone speak in public. When I had to speak I used to shiver and my hands would sweat. It was only discussions with our husbands or children, or amongst ourselves in the workshop, that taught us ways of speaking which made us feel as if we were really fighting . . .

This started us thinking: the women who have to face all sorts of problems, problems which male workers don't have to face, why are we frightened? Is it because we are women starting a struggle?

—woman factory worker
Lima, Peru

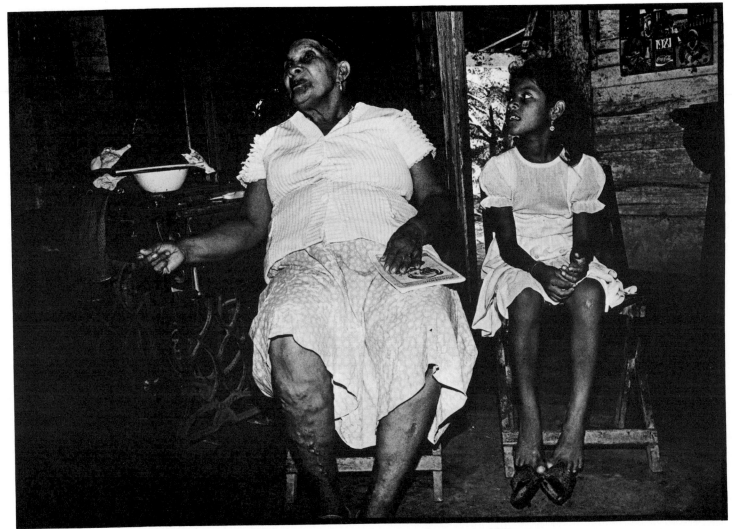

Grandmother and granddaughter, from La Chocolata, in the extreme southern part of Nicaragua.

At nine o'clock I got off the machine. I went to the restroom and I started telling everybody, "Let's go!" Then I started walking through the middle of the—where all the people were working—they thought I was very happy. And they started, "Alma, Alma!" And everybody started getting off the machines. I couldn't believe it. It was something so beautiful, so exciting.

And then suddenly a supervisor got a hold of me on my shoulder, and he says, "Alma, we need you! Don't go." So everybody started . . . I took a lot of people that were real good. I took them all out with me.

When I started walking outside, all the strikers that were out there, yelling, they saw me, and golly, I felt so proud, 'cause they all went and hugged me. And they said, "We never thought you were one of us." And I said, "What do you think? Just because I'm a quiet person?"

—Alma, one of the 85% of the Farah Manufacturing Company workers who were women, during the 1972-1974 strike at El Paso, Texas.

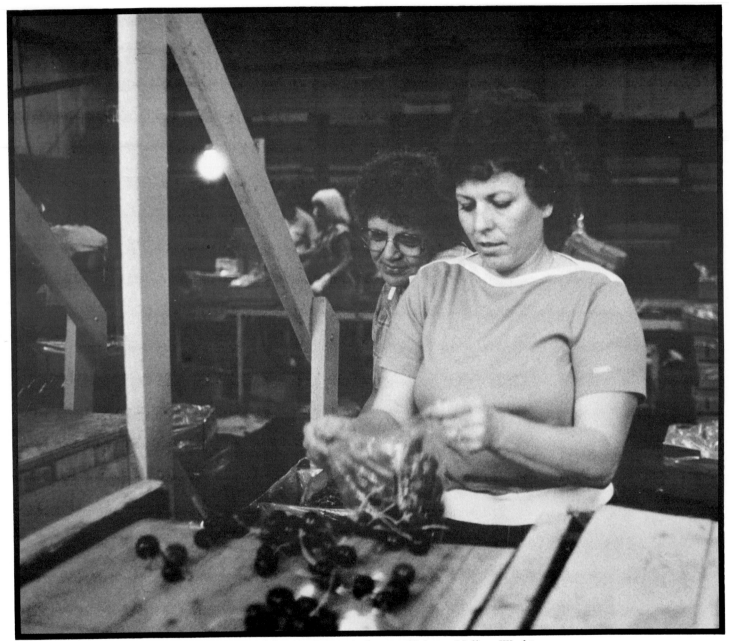

These women share as they select cherries in a fruit processing plant in Yakima Valley, Washington.

. . . *this poem is for you*

a sparrow poem
about a bird
that flew into the factory
when the overhead door was open

how the poor thing flew around and round
just missing steel beams and machinery
and electric cables
and how everyone felt so sorry for it
wanting it to get out
hoping it would get out

workers
women and men running
to open all the windows
all the doorways that they could
and when the sparrow flew to freedom
how everyone cheered

how I would cheer
to be able to read your poems
and you could read mine
trading them like trading cards
or comic books
like kids
we'd be so happy
to know we each existed

so keep on writing
of coffee breaks
and Emma's new tool box
and the first steps
Wally's baby took
and how the third shift
let the air out of the scab's car tires
on Martin Luther King's birthday . . .

—Sue Doro, first and only woman machinist
on the Milwaukee Road Railroad.

Women work in a cherry cannery in Yakima Valley, Washington. -

I was a little chubby . . . so when I was in fifth grade I used to have this fantasy that I was a cowboy. This excess weight I had was just sort of like props that I had on my body, and when I would leave the classroom, I'd take off this excess weight and put on my cowboy suit and get on my horse and ride away.

—A lesbian recalls the fifties,
from the Buffalo Women's
Oral History Project, Buffalo, New York.

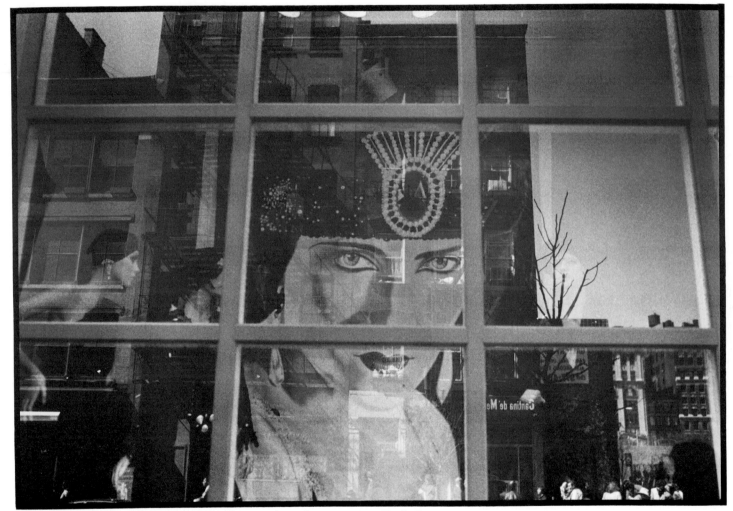

The reflection sees us and we see ourselves in the reflection. New York City.

The life was dangerous. Straights would beat you up . . . just come down to the bars looking to beat us queers . . . (there was) persecution and harassment. You had to walk down the street in pairs. Lots of us had to look real tough because underneath we weren't really secure about ourselves. We were scared . . .

. . . It leaves you with a lot of bitterness . . . You tell me about archives—you know where mine are? Scratched on a shithouse wall!

—Lesbians recall the fifties,
from the Buffalo Women's
Oral History Project, Buffalo, New York.

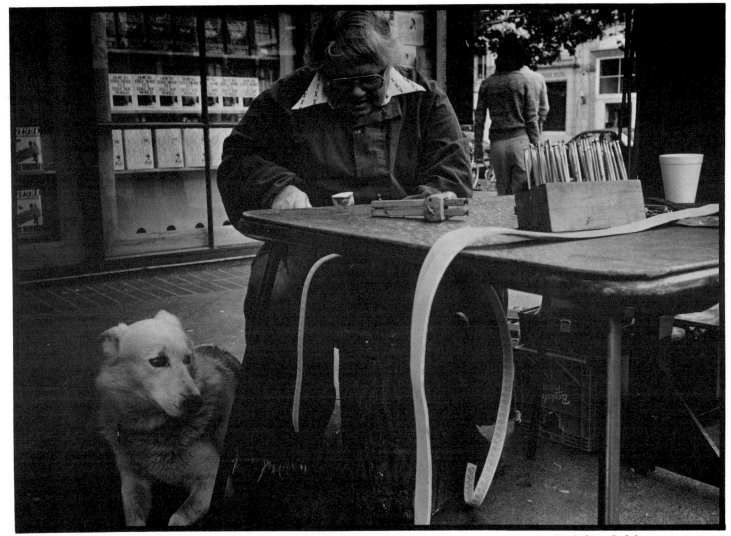

Dorothy supplements her inadequate retirement pay making and selling belts on a street corner in Berkeley, California.

Poem for a Friend

"Do you live alone?"

"No, I live with a friend."

I live with a friend
A friend
 whose life is hopelessly intertwined with mine
with whom I have long since crossed the boundaries
of friendship

A friend a comrade a family & a lover

"This friend I live with is a lover."

"Oh! Where did you meet him?"
"Oh! What's his name? What does he look like? Do I know him?"

This friend I live with is a lover is a woman
 is a woman
(Is that you blushing or is it me?)

This friend I live with is a lover is a woman is the best
friend I have and deserves
to be called a lover deserves
to be spoken of without averted eyes
deserves to be treated as
a friend a comrade a family & a lover

This friend I live with
 this lover
 this woman
my friend.

—Debbie Wald

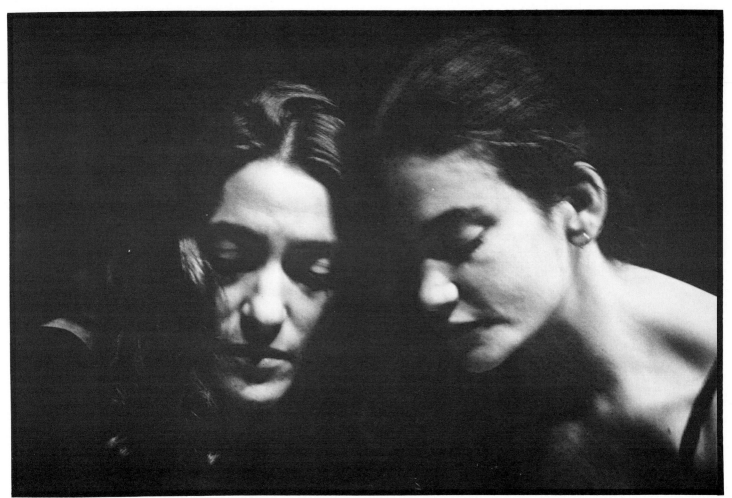

Two women from the Wallflower Order Dance Collective at a discussion after rehearsal. Managua, Nicaragua.

I know that in the rest of my life, the next half-century or so, every aspect of my identity will have to be engaged. The middle-class white girl taught to trade obedience for privilege. The Jewish lesbian raised to be a heterosexual gentile. The woman who first heard oppression named and analyzed in the Black civil rights struggle. The woman with three sons, the feminist who hates male violence. The woman limping with a cane, the woman who has stopped bleeding, are also accountable. The poet who knows that beautiful language can lie, that the oppressor's language sometimes sounds beautiful. The woman trying, as part of her resistance, to clean up her act.

—Adrienne Rich

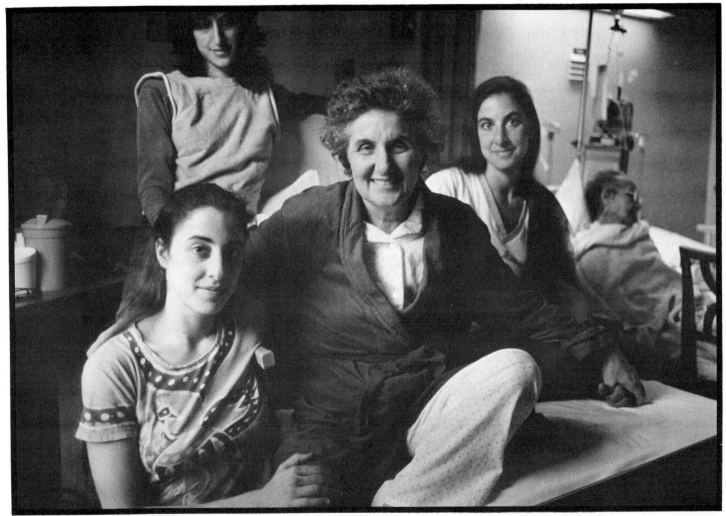

Shirley has just had a radical mastectomy. Her daughters come from different cities to be with her. Philadelphia.

You know, it wasn't that high up, it was only about ten, twelve feet, but, oh, I couldn't believe it, the guys were carrying me out, they wanted to know if I could move, they wanted to put me on my back on a stretcher, and I says, "Oh, my back, I can't handle it, the pain is too bad." So they lay me on my side, which is bad enough in all the little kitty-corners they had to go around to get me down. And they were absolutely white, they were absolutely sheer-white. And I looked up and I says to them, "Where the hell's your sense of humor?"

—Fragment of a long interview with
Buffalo ex-steelworker Mary Dean.

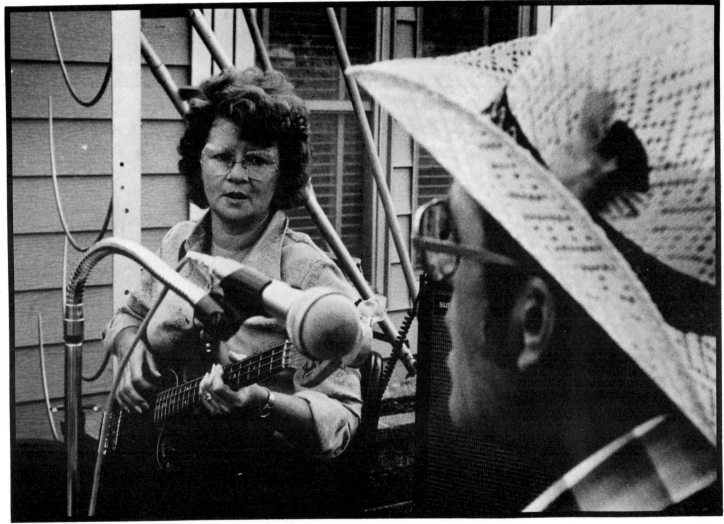

Country and Western singer. Yakima Valley, Washington.

Goddamn the Empty Sky

Goddamn the empty sky
and the stars at night
goddamn the ripply bright
stream as it goes by
goddamn the way stones lie
on dirt and on the street
goddamn the oven's heat
because my heart is raw
goddamn the laws
of time the way they cheat
my pain's as bad as that . . .

Goddamn the moon and weather
desert and river bed
goddammit for the dead
and the living together
the bird with all its feathers
is such a goddamn mess
schools, places to confess
I tell you what I'm sick of
goddamn that one word love
with all its nastiness
my pain's as bad as that.

So goddamn the number eight
eleven nine and four
choir boys and monsignors
preachers and men of state
goddamn them it's too late
free man and prisoner
soft voice and quarreler
I damn them every week
in Spanish and in Greek
thanks to a two-timer
my pain's as bad as that.

—Violeta Parra, Chilean folksinger,
composer and poet.

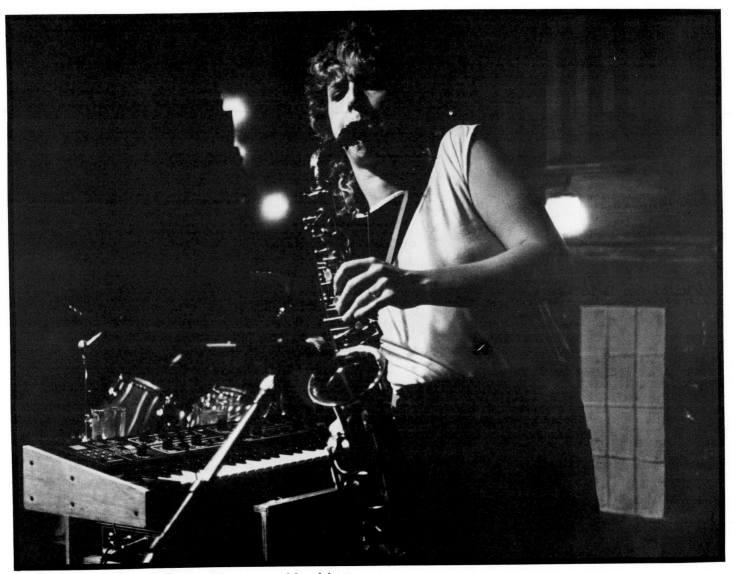

Laura is a wonderful saxophonist. Albuquerque, New Mexico.

Young Farm Woman Alone

What could I do with a man?—
pull him on like these oxhide boots,
the color of plums, dipped in blue ink
and stomp hell out of my loneliness,
this hoe that with each use grows sharper.

—Ai

Boutique in Sausalito, California.

Black Woman

. . .

This is the land where I suffered face down and whiplash.
Bucking her rivers.
Under her sun I planted and gathered
harvests I did not eat.
A barracoon was my home.
I myself carried the stones to build it
as I sang to the natural rhythms of this country's birds.

 And I rose up.

Here on this land I touched the blood
and rotting bones of others
brought here, or not, as I was.
And I never again imagined the road to Guinea.
Was it to Guinea? Benin? Was it to Madagascar? Or Cape Verde?

 I worked much more.

I gave greater touchstone to my ancient song and hope.
I built a world here.

 And I went to the hills.

My true independence brought me on stage
and I rode with Maceo's troops.
Only a century later
with my descendants
from that blue mountain

 would I come out of the hills

to put an end to capital and moneylenders,
generals and bourgeoisie.
Now I am.
Only today do we have and make.
Nothing is lost to us.
Ours the land.
Ours the sea, the sky.
Ours the magic and the rage.
My equals,
here I watch you dance
around the tree we placed in the ground for communism.
Her prodigious wood already sounds.

—Nancy Morejón, Cuban poet

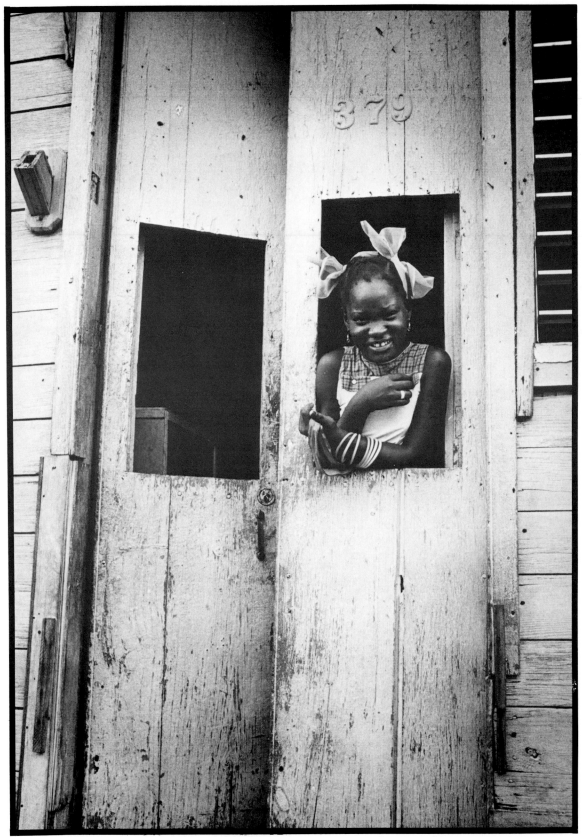

In Havana's Cerro district, a young girl looks out from a peep window in a door.

Black Mother Woman

I cannot recall you gentle.
Through your heavy love
I have become
an image of your once delicate flesh
split with deceitful longings.
When strangers come and compliment me
your aged spirit takes a bow
jingling with pride
but once you hid that secret
in the center of furys
hanging me
with deep breasts and wiry hair
with your own split flesh and long suffering eyes
buried in myths of no worth.

But I have peeled away your anger
down to its core of love
and look mother
I am
a dark temple where your true spirit rises
beautiful and tough as a chestnut
stanchion against your nightmares of weakness
and if my eyes conceal
squadrons of conflicting rebellions
I learned from you
to define myself
through your denials.

—Audre Lorde

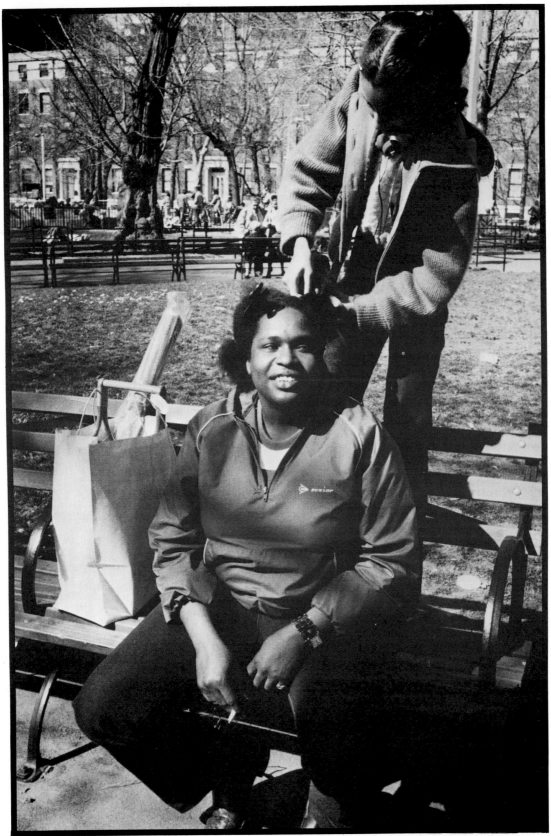

In Manhattan's Washington Square Park, a daughter combs and arranges her mother's hair.

Barcelona Journal. V.

Time. I think on the way to the park of time.
Of how, at the same instant, I feel both the ex-
tension and the lack of it. As if there were a
moment, somewhere, hidden, that if touched
would open the heart of the world to me. And
then, turning my head, I see the hills, so
green, so full, they seem without time, without
extension. Even the broken bottle in front of
me is part of it. A piece of mirror; a small
black ant. A breeze so gentle it is almost in-
distinguishable from the movement of children
racing by. An edge of clouds. And the sun.
The sun! Its very heat forcing me finally to
turn away.

—Susan Sherman

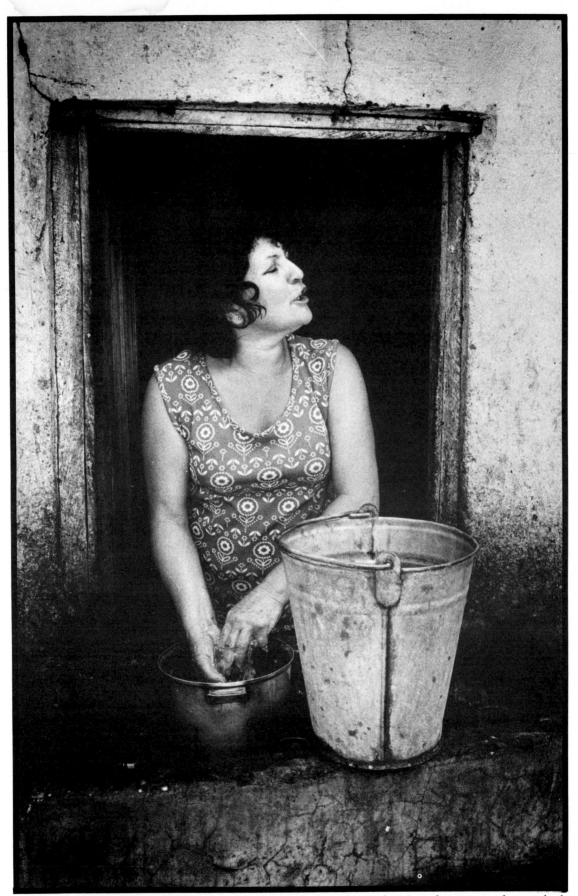

A peasant woman washes dishes after feeding her family and friends. Near the provincial capital of Victoria de Las Tunas, Cuba.

If you have the concept of history as a circle, nothing is lost. Everything is reiterated, and your shit falls on you eventually. I mean, you just can't pollute the rivers. It's going to turn, as we find it's doing. It returns as poison, as death.

I believe that women have this to contribute to our world, this knowledge of the cyclical return. I mean, women know that the seed germinates and something is born. And they know that society is also a womb and what is planted today—the radical—returns. The radical simply means root. The root returns. So this planting of the old radical world is still there, still alive, still to be born out of the old root the new revolutionary reality.

—Meridel LeSueur

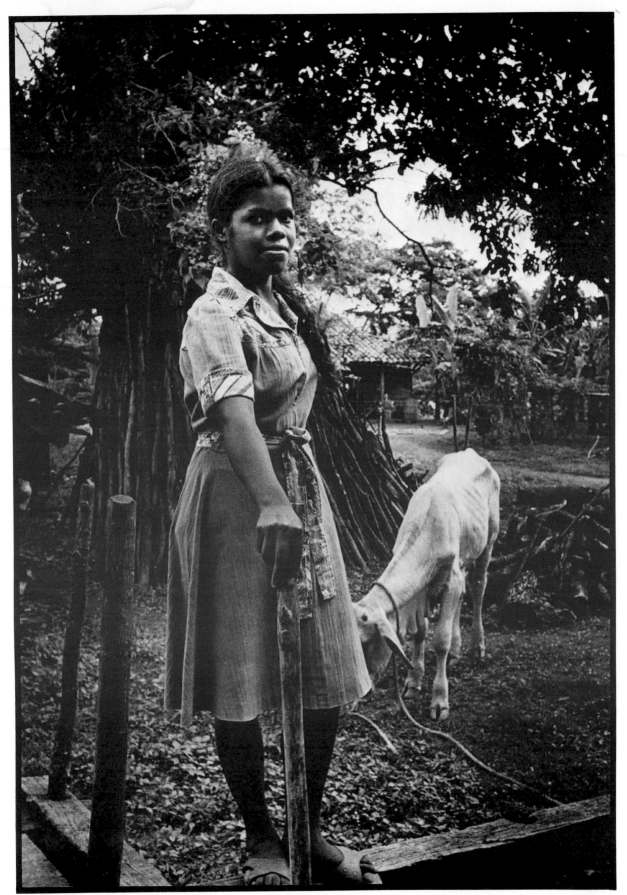

In the tiny community of La Chocolata, Nicaragua, thirteen-year-old Olga Marga looks out at the world.